The Campus History Series

STATE UNIVERSITY
OF NEW YORK
AT POTSDAM

The Campus History Series

STATE UNIVERSITY OF NEW YORK AT POTSDAM

Jane M. Subramanian and Virginia Rose Cayey

ARCADIA
PUBLISHING

Published by Arcadia Publishing
Charleston, South Carolina

Printed in the United States of America

Library of Congress Catalog Card Number: 2011927753

For all general information, please contact Arcadia Publishing:
Telephone 843-853-2070
Fax 843-853-0044
E-mail sales@arcadiapublishing.com
For customer service and orders:
Toll-Free 1-888-313-2665

Visit us on the Internet at www.arcadiapublishing.com

With heartfelt appreciation, we dedicate this work to all past, present, and future students, administrators, faculty, staff, and alumni. Each and every one of our college community over the years has together made this college all that it is.

CONTENTS

ACKNOWLEDGMENTS

The coauthors wish to thank several people who have contributed in several different ways in order to make this publication possible, including SUNY Potsdam alumna Dorothy Albrecht Gregory, class of 1961, whose financial support made it possible for us to be able to proceed with this publication of our college's history; Jenica Rogers, SUNY Potsdam director of libraries, and Jason Ladouceur, SUNY Potsdam director of planned giving, both of whom strongly supported the creation of this work for our campus and worked to make it possible; Mark Huff, chair of SUNY Potsdam's art department, who was invaluable in repairing some damaged photographs; SUNY Potsdam students Amanda Allen and Megan Comins, who assisted with searching for additional information for some of the photographs and their content; James Cayey, husband of coauthor Virginia Cayey, who helped with whatever was needed whenever it was needed with full effort; SUNY Potsdam alumna Amelia Amoriell, class of 1971, and Gerald Ratliff, associate vice president of Academic Affairs, who read the introduction of this work and provided excellent advice; Erin Vosgien, our acquisitions editor at Arcadia Publishing, who always provided helpful and excellent information promptly; Deborah Dudley, SUNY Potsdam's head of marketing, who provided good advice related to use of images; and Doug Klostermann, travel, culture, and humanitarian photographer, who provided help with the St. Lawrence Academy plaque photograph.

Unless otherwise noted, all images appear courtesy of the SUNY Potsdam College Archives and Special Collections. Some photographs owned by the archives have known photographers, and where available, this information is provided in the particular image caption.

INTRODUCTION

The State University of New York College at Potsdam traces its roots to the St. Lawrence Academy, founded in 1816 by land agent Benjamin Raymond. Thus begins the lengthy story of SUNY Potsdam, recognized as the oldest unit of the State University of New York's 64 campuses. The first class at the academy consisted of 42 students, and courses were held in a one-story frame building only 24 by 36 feet with a vestibule and a bell.

The student body of the St. Lawrence Academy grew rapidly, with 114 students enrolled by 1820. Students also were coming from longer distances even in these early years, representing Oneida and Clinton Counties within New York State, as well as many from Potsdam's own St. Lawrence County. Despite the challenges of travel during the early 1800s, students from Montreal and other towns in Canada were also attending the college. To accommodate the increasing number of students, a new building called the North Academy was constructed in 1821, and classes opened in that building in 1825.

When Rev. Asa Brainerd was hired as preceptor in 1828, the academy entered a particularly significant era. Reverend Brainerd's belief in the development of good training for teachers resulted in his establishing special teacher-training classes under a three-term system. As a result of his innovative coursework, Reverend Brainerd was the first school principal in New York State to make a systematic attempt to classify teacher training separately from other courses. Not long after, in 1835, the New York State Legislature acted to establish stronger programs for public schoolteacher preparation and designated one academy in each senatorial district within the state to receive money for a special teacher-training department. The St. Lawrence Academy received this distinction, and thus, the long and continuing tradition of teacher education at SUNY Potsdam was born. The first teachers' diplomas were awarded in 1836. The establishment of the teachers department resulted in the need to construct an additional building, and the South Academy opened in November 1837.

In the early 1840s, the New York State Legislature became interested in the normal school system of training teachers used in Prussia. The first normal school in New York State was opened in Albany in 1844, with a second opened in Oswego in 1861. Extensive competition throughout New York State ensued when the state decided to establish four more normal schools in 1866. Because the state funding for teacher training to academies ended at this time, the St. Lawrence Academy was especially interested in becoming one of the next four normal schools despite the strong competition from all corners of the state. Strong efforts by the St. Lawrence Academy trustees as well as the entire surrounding community resulted in success, and the state legislature designated the village of Potsdam as one of the four sites chosen for a normal school in 1867. The longtime reputation for successful teacher training of the St. Lawrence Academy was one element of the successful quest for Potsdam to be chosen for a

normal school, but another very significant aspect was the strength of the community's efforts. Local support included both extensive involvement and financial backing. Dr. Charles H. Leete summarizes the contribution well in the college's 1926 yearbook, titled *The Annual*: "After the Normal superseded the academy, the same pride, the same loyalty, the same hearty co-operation steadily characterized the relation between our community and its educational institutions." With the success of the college and community's efforts, the St. Lawrence Academy became the Potsdam Normal School. This school opened in a new building in April 1869, and the first class, comprising two members, graduated on February 7, 1871.

Even in the early years of the community and the college, music had always been important. The first appearance of music in the curriculum began in 1831 during the St. Lawrence Academy days. This set the stage for the college's next curricular innovation, which appeared around this same time period and marks the beginning of the long tradition of SUNY Potsdam's preparation of music teachers for public schools. In 1884, Julia Crane was appointed head of the Potsdam Normal School music department; with her tremendous leadership and insight, she founded the first normal training course for public school music teachers in the United States. From the early days of its establishment, the Crane School of Music, along with its earlier names, became particularly well known for its preparation of music teachers. Soon, a large number of its graduates were teaching not only throughout New York State but also throughout the country. Current estimates indicate that more than half of music teachers in New York State are Crane graduates, with music graduates also found teaching in every state in the country.

As the college moved into the 20th century, both physical and curricular changes were evident. The Potsdam Normal School demolished the first normal school building in 1917 and constructed at the same location a new classroom/administration building, which opened in 1919. This same structure is now Clarkson University's Snell Hall on its older downtown campus. The curriculum of Potsdam Normal gradually changed over this same time period, with both the teacher and music education curricula first lengthened from two-year to three-year programs; by the late 1930s, all were four-year programs. By official action of the New York State Legislature and the governor, the Potsdam Normal School became the State Teachers College at Potsdam in 1942, the same year that the first bachelor's degrees were granted. Master's degrees were subsequently authorized in 1947. Yet another significant change appeared in 1948 when the State University of New York was established, and the campus became part of the large statewide system as the State University of New York Teachers College at Potsdam.

Along with this latest name change, the college also began a significant physical transition as it relocated to the present Pierrepont Avenue campus, with the first new structures appearing at this location in the early 1950s. Once the clock tower was constructed on the main building for the new campus, it quickly became a major symbol of the college and has been used ever since. A number of additional buildings were constructed from the mid-1950s to 1973, resulting in the campus as we know it today.

Additional name changes occurred in 1959, when the college became the State University College of Education at Potsdam, and in 1961, the name was again changed, this time to the State University of New York College at Potsdam. This reflected the expansion into more liberal arts programs, joining those for teaching. The School of Liberal Arts and the School of Professional Studies were both formed in 1972, later becoming the School of Arts and Sciences and the School of Education and Professional Studies, respectively.

The size of the student body has continued to grow throughout the years, with enrollment now over 4,000. The number of academic programs has expanded as well, with more than 40 majors and 40-plus minors available to students. Some traditions have remained, while others have come and gone, the creation of newer traditions taking their place. Throughout the long history of the campus, the college administrative leaders, faculty, staff, students, and alumni have all contributed to make the college what it is and help form the SUNY Potsdam story.

Although the school has changed in many ways over the years, one longtime campus resident has made the campus her home for many of those years. The statue *Minerva* was donated by the

class of 1892. She has moved from the old Potsdam Normal Building to the new Potsdam Normal Building, from the new Potsdam Normal Building to Satterlee Hall (originally Raymond Hall), and from Satterlee Hall to the lobby of Crumb Library. A duplicate statue of Minerva designed for outside conditions was made from the original statue and is found in the new outdoor space appropriately named Minerva Plaza. The original *Minerva* has more recently moved from the lobby to Minerva's Café within the library, where she enjoys continuing interaction with students and faculty. Undoubtedly, she will continue to see our campus through future changes in good stead, and she will continue to participate in the lives of all past, present, and future students.

The photographs presented in this work give a good glimpse of the history of the college from its earliest days to the mid-1980s. Much greater emphasis has been given to earlier years since this period is more distant from us in time, and much of that content is no longer visible on campus. Given the lengthy history of the college, certain aspects could not be included in this work. For those who are interested in further exploration, extensive resources documenting the history of SUNY Potsdam are located in the College Archives and Special Collections, including publications, documents, photographs, audio recordings, moving images, and digital material. A permanent exhibit on the history of the college, for the enrichment of not only the entire campus community but also visitors to SUNY Potsdam, is available in the Mary E. English Commons located in Satterlee Hall. Although it is impossible to represent the entire history of the college fully within these pages, it is hoped that this representative sampling of photographs will give readers a strong sense of the people, places, events, and impact of SUNY Potsdam in the state and throughout the nation. Together, these form the wonderful and fond memories of our campus community and its graduates.

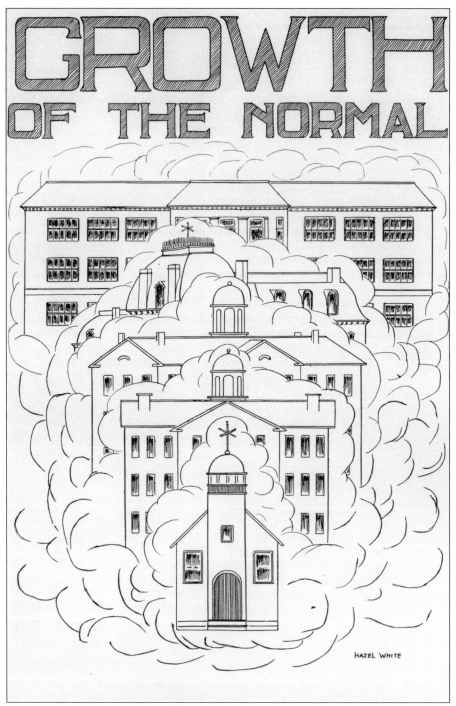

GROWTH OF THE NORMAL

HAZEL WHITE

Potsdam Normal School student Hazel White, class of 1928, created this wonderful artistic depiction of the growth of the normal school for the 1928 yearbook, which contained much historical information about the college. Her sketch shows the different structures of the St. Lawrence Academy and the Potsdam Normal School through that time period, with each building on the previous one.

One

THE EARLY YEARS AS THE ST. LAWRENCE ACADEMY

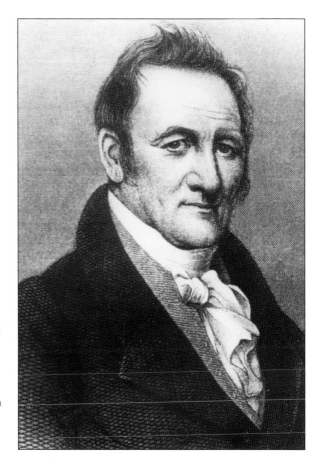

Benjamin Raymond was a land agent for the Clarkson family and was one of the most significant individuals in the founding of both the town of Potsdam and the St. Lawrence Academy. The first school in Potsdam was held in Raymond's home before a separate academy was constructed on one of his properties.

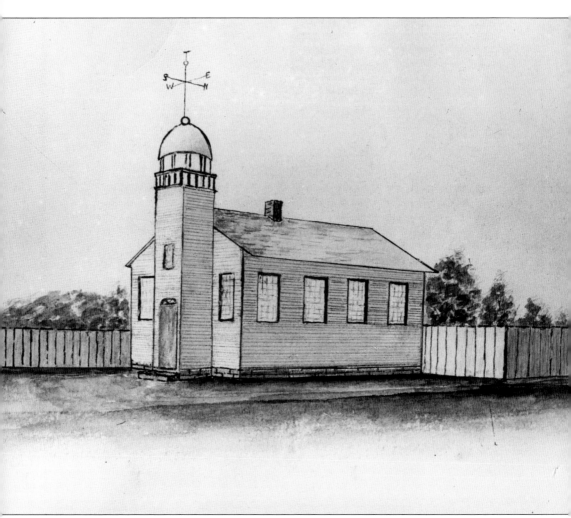

This is a sketch of the first building of the St. Lawrence Academy, which was established in 1816. A local board of trustees oversaw curriculum, finances, and personnel. Bylaws were adopted that included reference to the Sabbath Day, conduct, and curfew. Tuition was determined and was paid each quarter, with the amount calculated according to which courses were taken. Reading and writing were each $2.50; English grammar, ciphering, and mathematics were $3; dead languages were $3.50; and the most expensive, at $4, were logic, rhetoric, composition, philosophy, and French. Students also paid about $2.50 per week for room and board in local homes. The academy opened with an enrollment of 42 pupils, and Nahum Nixon was hired as principal and teacher. More students began to enroll not only from local areas but also from nearby counties and Canada. This is the only known rendition of the building, since it was replaced with the new North Academy building in 1826 before photography was available. The new building was needed because of increased enrollment.

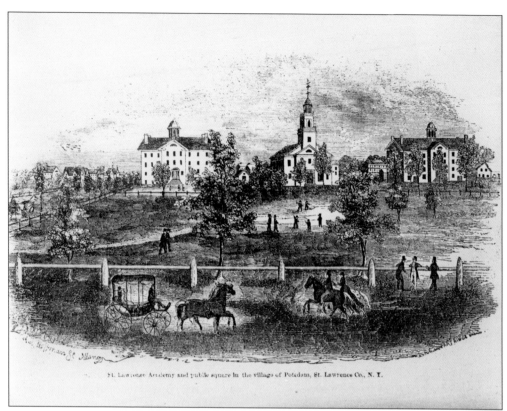

St. Lawrence Academy and public square in the village of Potsdam, St. Lawrence Co., N. Y.

This drawing shows the Presbyterian church flanked by the North and South Academies. In addition to classrooms, the North Academy (left) had a chapel, library, and dormitory space. The new buildings were placed on the public square between Elm Street and Main Street across from what is now the Potsdam Civic Center.

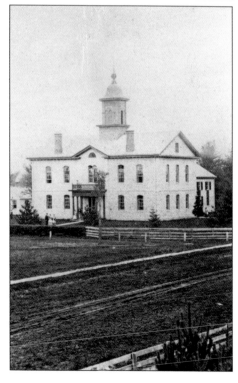

State aid for teacher training led to a further increase in enrollment and the need for additional classrooms and more dormitory space. The South Academy building opened in 1837. This is the first known photograph, from around 1850. The first floor was used primarily for the teacher department classrooms while the upper floors included dormitories and a recitation room.

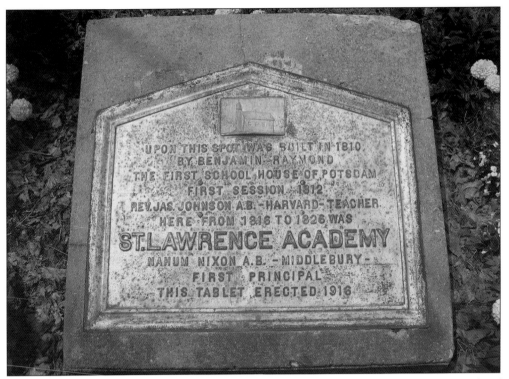

The original location of the St. Lawrence Academy is marked by a plaque on the west side of Union Street between Main and Elm Streets. It was placed there on the 100th anniversary of the founding of the academy. This area was also the site of one of Benjamin Raymond's properties. (Photograph by Jane Subramanian.)

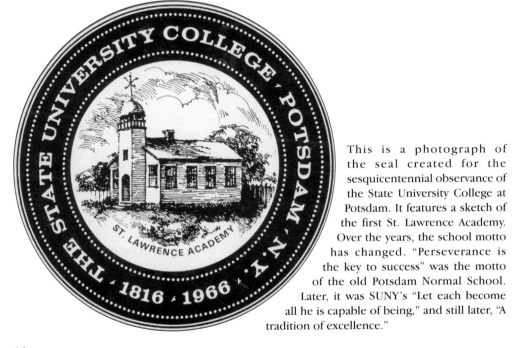

This is a photograph of the seal created for the sesquicentennial observance of the State University College at Potsdam. It features a sketch of the first St. Lawrence Academy. Over the years, the school motto has changed. "Perseverance is the key to success" was the motto of the old Potsdam Normal School. Later, it was SUNY's "Let each become all he is capable of being," and still later, "A tradition of excellence."

Two

Potsdam Normal School Academics, Places, and Student Life

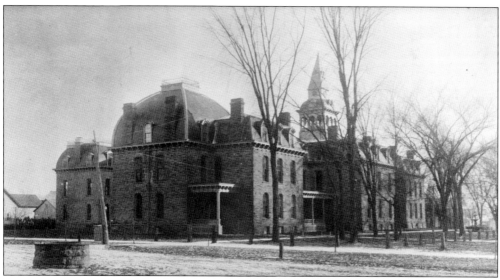

By 1830, the training of teachers was made a regular part of the work of the academy. Students who had preparation in the principles of teaching went out to instruct in the public schools. In 1867, when the state authorized the establishment of normal schools, Potsdam was chosen as one of the locations. The academy buildings were demolished, and a new Potsdam Normal School (pictured here) was constructed on that site.

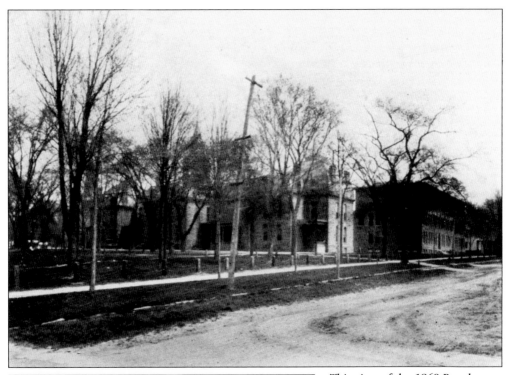

This view of the 1869 Potsdam Normal School, taken from the Main Street side, also shows the Stowell Annex (back right). Named for Dr. Thomas B. Stowell, it was completed in 1889 and contained a gymnasium with running track, apparatus, showers, and lockers.

Through these doors and others like it have come and gone thousands of graduates. The number of faculty and staff has grown extensively since the St. Lawrence Academy days of one "principal-teacher." Today, alumni are living in all 50 states, Guam, Puerto Rico, US Virgin Islands, and over 30 countries. Potsdam's history, traditions, and spirit have spread all over the world.

Malcolm MacVicar became the first principal of the newly built Potsdam Normal School in 1869 and remained there for 11 years. He had a keen interest in teacher training and methods of instruction, and he assisted in organizing the practice school for teachers in training. He was an author and inventor of various devices to illustrate objectively the principles of arithmetic, geography, and astronomy.

In 1869, Amelia Morey was hired by Dr. MacVicar to be principal of the Intermediate Department of Potsdam Normal. There, she distinguished herself for her executive ability. Seven years later, she was made preceptress of the practice school, where she worked with and inspired student teachers. She was offered positions in other places at higher salaries but remained in Potsdam, where the school's success was, in so many ways, due to her efforts.

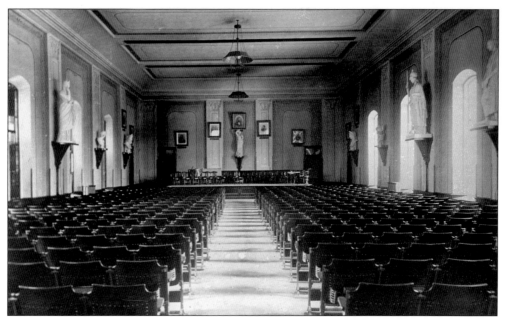

Each day for morning exercises, students processed silently into the chapel of the first Potsdam Normal. This hall was also the site for Wednesday afternoon rhetoricals. The sides of the chapel were lined with statues and busts of classical significance, including authors, gods, goddesses, and philosophers. Today, the locations of these statues are unknown except for *Minerva*, who remains the most revered member of the college community.

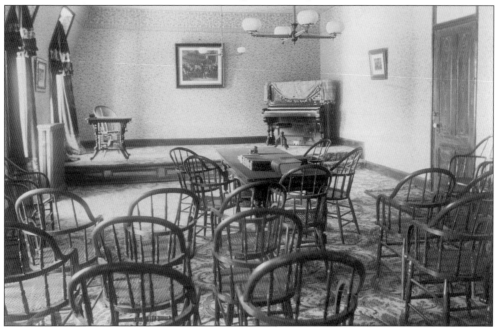

Literary societies were an important part of academic life and can trace their beginnings as far back as 1834. They held private meetings that included recitations, debates, musical recitals, and comedy skits. Pictured here is one society's room, thought to be on the third floor of the first Potsdam Normal Building.

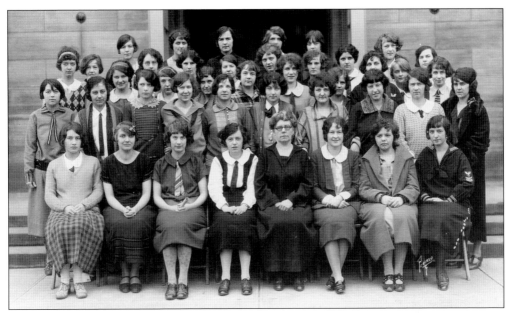

Following the Potsdam Normal opening in 1869, the Alpha Society was organized. It was a literary society exclusively for Potsdam Normal women and was established for the improvement of composition and debate. Since women of the time were not encouraged to express opinions in public, this gave them a chance to do so behind closed doors. This photograph was taken in 1925, more than 50 years after the society was organized.

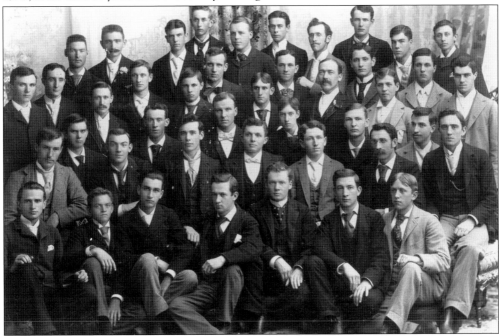

The Baconian, a men's literary group, was formed as a companion society to the Alphas. It was a very popular organization and by 1876 had grown so large that it was divided into two groups, the Roger and the Francis Baconian Societies. The event of the year was the Grand Public Debate, in which one member from each of the societies was chosen to participate.

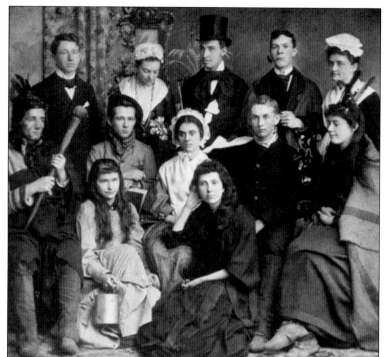

In the early 1880s, the women formed a second society, the Calliopeans. Society meetings were usually held behind closed doors, as the members practiced their craft in front of each other. They occasionally had joint or open meetings and held public debates. These Baconian and Calliopean students are still in their costumes after having performed a skit during one of their joint meetings.

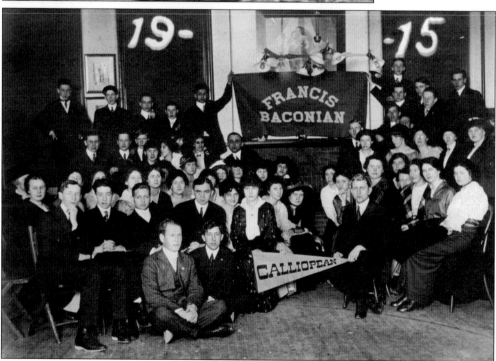

About 1926, the groups separated. The Baconians became a high school organization, and the Alpha and the Calliopean societies became the sororities Alpha Sigma Nu and Zeta Gamma Upsilon. Other literary societies also became social organizations. These sororities became an integral part of college life, fostering pleasant social relations and friendships.

Dr. H.E. Cook, principal of Potsdam Normal from 1884 to 1889, was familiar with architecture and sanitary science. He enlarged, remodeled, improved, and equipped the building and drew up plans for a large annex. Julia Crane also began at the school in 1884. Cook paved the way for Crane to have more time and facilities to pursue her idea of giving students formal training in methods of teaching public school music.

Dr. Thomas B. Stowell served as principal of Potsdam Normal from 1889 to 1909. He was a well-known scientist and a progressive administrator. Stowell viewed student life as an integral part of the educative process and recognized the force of the teacher's personality on the lives and ambitions of students. He advocated for new programs in the sciences, vocational training, and physical education in the public schools.

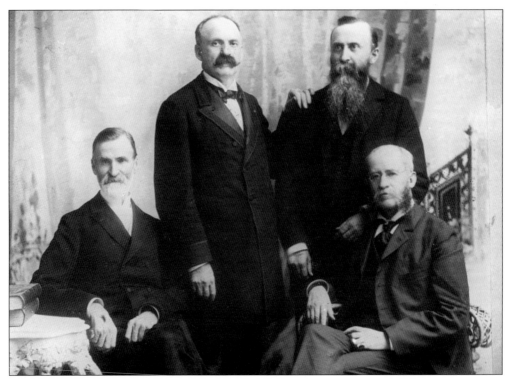

Pictured here are the first four principals of Potsdam Normal School, each of whom spoke at the 25th anniversary exercises of the Potsdam Alumni Association. They are, from left to right with dates of service, Dr. Malcolm MacVicar, 1869–1880; Dr. E.H. Cook, 1884–1889; Dr. Thomas B. Stowell, 1889–1909; and Gen. Thomas J. Morgan, 1881–1883. The celebration was held in the Potsdam Opera House on June 27, 1894.

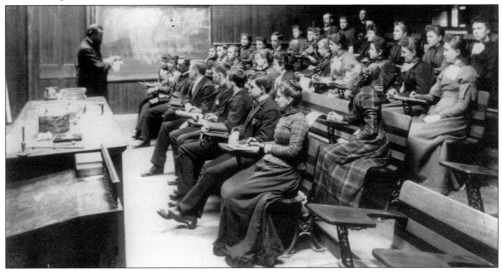

Located in the first Potsdam Normal Building of the downtown campus, this is an early class taught by Dr. Thomas B. Stowell in 1891. The coed tradition of the academic institution existed from the early days of the St. Lawrence Academy. The hard wooden seats in classrooms from the 1800s through the mid-1900s were functional but not very comfortable for the students.

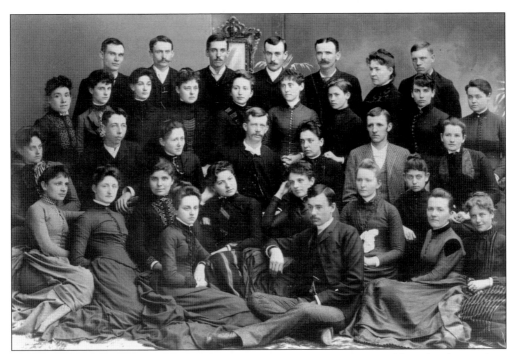

Thirty-three students are posed in this photograph of the class of 1888, although other sources show as many as 52 graduates that year. It is known that in the earlier days two graduation ceremonies were held each year. One commencement was held in February and one in June, as the students finished their coursework.

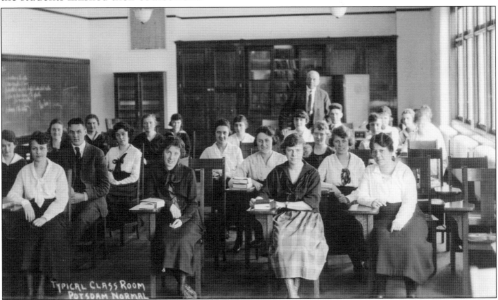

The pamphlet *Our Goodly Heritage* was published by the college in 1934 to celebrate the 100th commencement. Students honored their teachers by stating, "For many alumni Potsdam Normal School is personified in the characters of favorite teachers. Each year there have been instructors beloved by their students and called to mind affectionately whenever alumni or students assembled. Among those who have created our heritage the faculty are second to none."

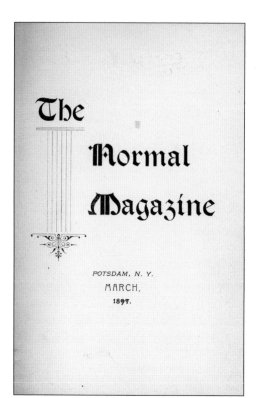

The Normal Magazine

POTSDAM, N. Y.
MARCH,
1897.

The Normal Magazine, the first alumni magazine, was published in 1897 with Julia Crane as editor. The purpose was to bring alumni into closer touch with the school by providing news of the college community. Although the name has changed through the years, the magazine has been published almost continually since its debut. It is known today as *Potsdam People*.

Physical culture was brought to the forefront during the Stowell era. At first, concentration was on calisthenics or "free exercise." Later, organized athletics made their appearance. Stowell eased restrictions on social gatherings between men and women, and in the early 1900s, the annual Delphic Fraternity Ball and the Baconian and Calliopean Banquet were held in the gymnasium.

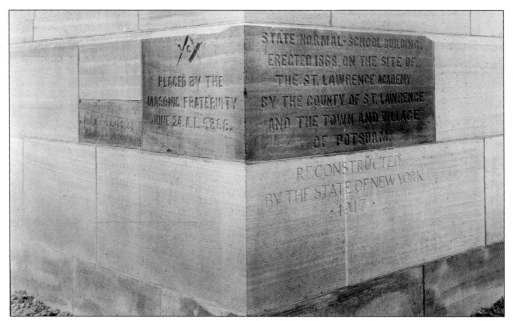

These cornerstones are on the north side of the former Potsdam Normal School. This building, now called Snell Hall, is owned by Clarkson University. Seen at left is the small, dark, 1825 cornerstone of the North Building of St. Lawrence Academy. Adjacent is the 1868 cornerstone of the first Potsdam Normal School. Both buildings were on this site. Beneath these stones is the larger cornerstone of the present building, which opened in 1919.

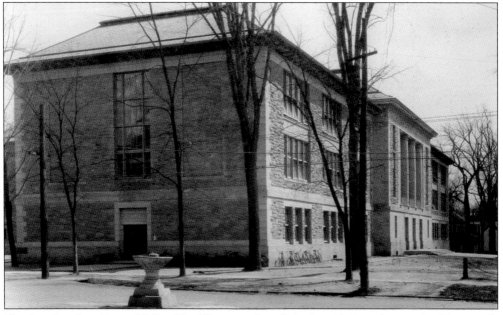

The first Potsdam Normal School building was demolished in 1917, and a new building made of Potsdam sandstone, like its predecessor, was erected on the same site. The new Potsdam Normal Building (pictured here) was opened 50 years after the opening of the first normal building, in 1919. Stones from the St. Lawrence Academy and the first normal building were incorporated into the innermost walls of the new structure.

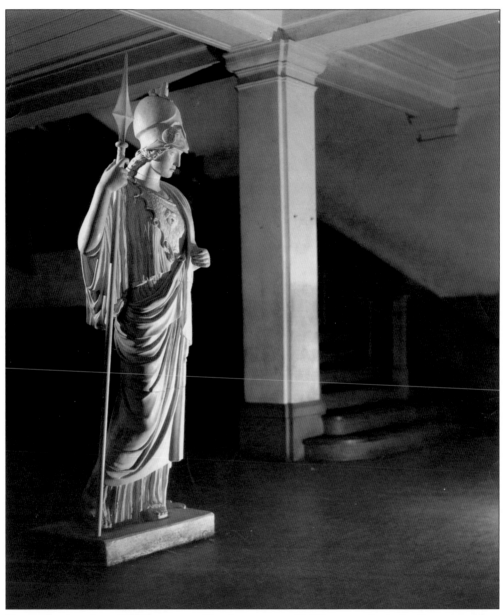

The graduating class of 1892 presented its alma mater with *Minerva*, who is the Roman goddess of wisdom, science, and the arts. She was placed on a pedestal hung on the wall in the Potsdam Normal chapel along with other similar statues, and she watched over all during the many events that were held there. In 1919, when students and faculty moved into the new Potsdam Normal Building, so did *Minerva*. She was placed just inside the front doors in the main lobby to greet all as they entered. *Minerva* was a convenient place to meet a friend or colleague, and "Meet me at Minnie" became a familiar phrase. She would listen silently to the conversations and keep all of the secrets heard. She thus had a vast knowledge of the life of each student. One student wrote in the 1928 yearbook, "In years to come, when we return to Potsdam Normal, when classes have gone and faces are strange, there will always be this one familiar one to greet us—Minerva."

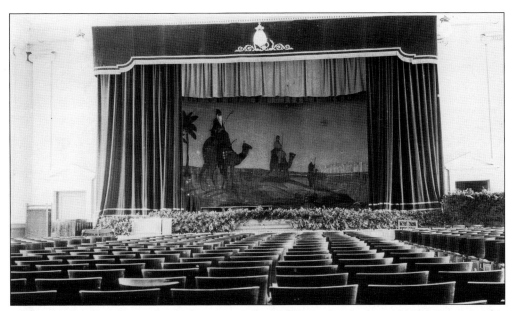

Classes opened in the new Potsdam Normal Building in September 1919. As seen in this photograph, there was a large auditorium, which included a four-manual pipe organ. Although the building was not entirely completed, during the first year both the 1919 commencement exercises and the 50th anniversary banquet of the Potsdam Normal School were held there.

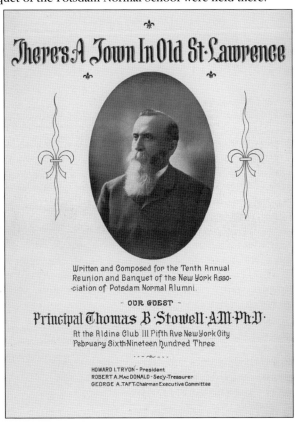

Pictured here is the cover of the sheet music "There's a Town in Old St. Lawrence," with music by Beatrice MacGowan and lyrics by Grace Goodale, class of 1893. It was composed for the 10th Annual Reunion and Banquet of the New York Association of the Potsdam Normal Alumni. The festivities were held on February 6, 1903, at the Aldine Club, Fifth Avenue, New York City. The honored guest was the principal, Dr. Thomas Stowell.

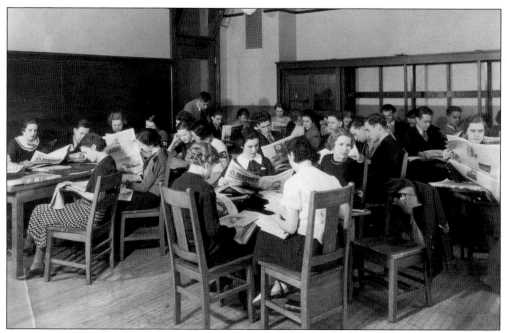

In this classroom scene, students are sitting informally around tables rather than in straight rows. They are all working independently reading a newspaper. Perhaps they are preparing for a debate or a group discussion on current events or politics in their social studies class.

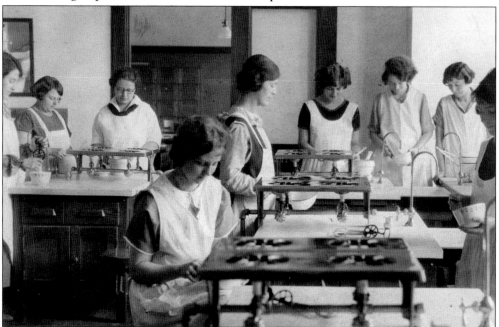

In times past, there were definite rules for running a proper home. Careful attention was paid to cleanliness, nutrition, meal planning, and the rules of etiquette. The second Potsdam Normal Building, which opened in 1919, had a domestic science department; and when the Potsdam Campus School opened in 1931, it contained a large room for household arts. This room was on the third floor across from the cafeteria.

An article in a *Normal Magazine* from 1900 informs the alumni that a new catalog system is in place in the library. It further indicates that it has been arranged in the form of a dictionary, making research for specific topics very easy. The article states, "It is a source of wonderment to us that we have so long existed without it." (Photograph by Dr. Parl West.)

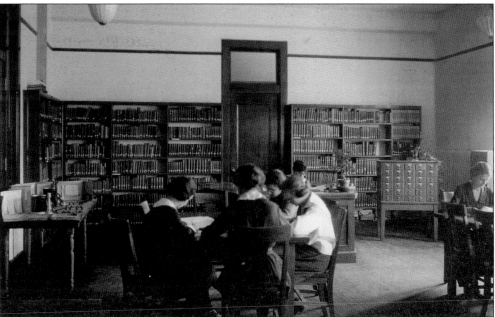

In 1825, when the North Academy building was constructed, space was provided for a library. Since that time, the library has been moved to each new building as the campus has expanded. In the 1920s, using funds donated in memory of Julia Crane, a small music library was started in the Potsdam Normal Building.

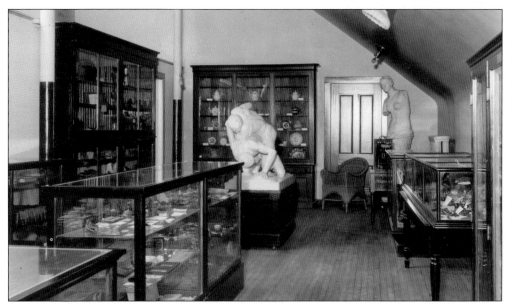

In 1928, Potsdam's first collection of historical artifacts and information was gathered by Jessica Reid, a history professor at Potsdam Normal. It was displayed in a case in the history department. Interested students, faculty, and alumni contributed to the collection. As the exhibit grew, it sparked an interest in establishing a museum. In 1932, opening ceremonies were held for Potsdam's first museum, which was located in the normal school.

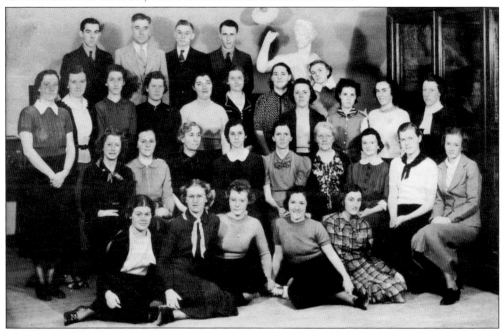

Members of the recently formed Normuso Society pose for a photograph in 1938. This society was formed to facilitate many cultural and worthwhile exhibits in the museum. These exhibits opened the way for the development of new interests among students, faculty, and townspeople. Many families whose ancestors were among the early settlers of Potsdam contributed generously to the permanent collection.

The first student council was formed in 1926. It was composed of four students from the senior class and three students from the junior class. Since the four-year curriculum did not begin until 1938, there was no sophomore class at that time. Here are pictures of the men's and women's student councils. Later, a faculty-student organization replaced the student council. These organizations acted on freshmen rules and the school constitution. They also oversaw the committee system. Committees shaped policies involving scholarship, social activities, public performances, welfare and housekeeping, finances, and the school newspaper, *The Normal Racquette*. The Athletic Committee worked to reestablish varsity athletics in 1943. Varsity teams disbanded during World War II as many of the male students joined the military.

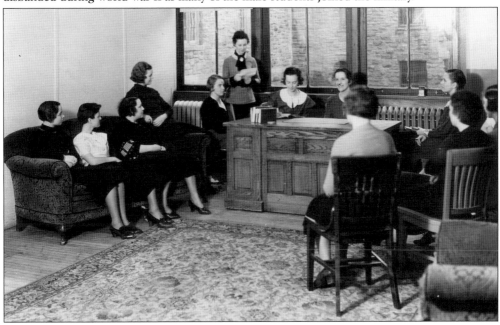

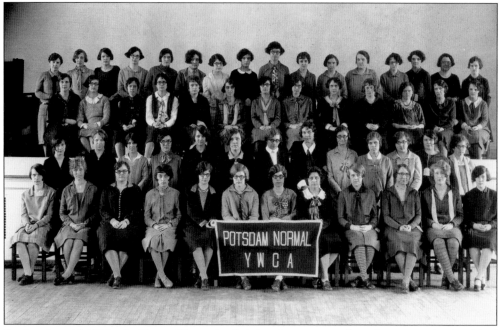

During the mid-1920s, the Young Women's Christian Association of Potsdam Normal School had the largest membership of any organization in the school, at about 125 members. The group promoted service, character building, loyalty, and good friendship among its members and to the school. This photograph shows about half of the 1927 membership.

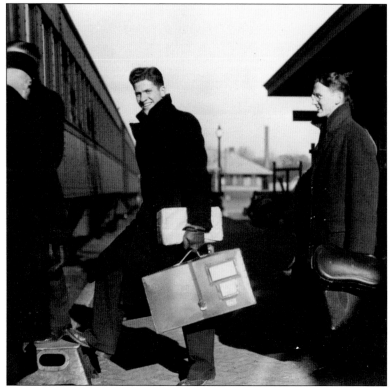

Railroads did not service Potsdam until 1850, but by the 1920s, there were as many as five passenger trains to and from Potsdam each day. In this 1936 photograph, students are departing from the Potsdam train station. Although passenger service ceased in the 1960s, the depot still survives in Potsdam as a restaurant. Transportation to and from Potsdam might actually have been easier in those early days.

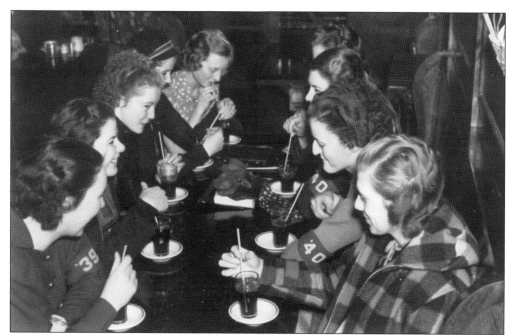

For a number of years, freshmen women were required to wear green armbands and freshmen men, red caps indicating their class year. They were worn for two semesters. In time, the rules changed, and identifying clothing was worn for only 10 weeks. In the early 1950s, women held armband-burning ceremonies at the end of the required wearing period. By 1956, both male and female students wore gray caps.

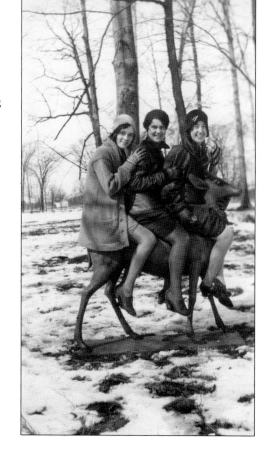

Written on the back of this photograph is "A favorite walk when we had free time on Saturday was to go up to what is now the Clarkson campus and sometimes 'ride the deer.' " Part of Clarkson College was located on the former Clarkson family estate on a hill just west of the village about a mile from the Potsdam Normal School.

THE RACQUETTE

Published Every Other Week During the School Year by Students of the State Teachers College, Potsdam, N. Y.

Z504 POTSDAM, N. Y., FEB. 4, 1944 No. 8

REIGN OVER ICE CARNIVAL

QUEEN ELLIOTT AND KING McELROY

The students' choice for 1944 Ice Carnival Queen, Betty Elliott, a native of Potsdam, has been a member of the athletic committee during her four years at college. Besides performing her royal duties this week, she is acting as co-chairman of the carnival.

During her sophomore year, Betty was "in the chips," being treasurer of her class. But just to show that she could use another kind of "do", she also sang in the college choir and played in band.

Her junior year took Betty to Massena, the showtown here, to do some practice teaching. Upon returning to Potsdam she acted as general chairman of the Junior Prom, which was held in the Civic Center—only last year.

Betty's classmates chose her as president of the senior class. It was this year also that she helped

Stag Dance Follows Arena Program

"Let's see — would this black weather go with that plaid shirt?"

"Does anyone have a clean pair of socks I could borrow, please?"

Musical Comedy Will Solve The "Minnie" Mystery, Feb. 16

Mrs. Falls, Mrs. Flynn Substituting in Grades

Mrs. E. K. Falls, of Potsdam, and Mrs. Elda Flynn, of Norwood, are teaching as temporary substitutes in the School of Practice seventh grade and in the Pine Street school, respectively. Mrs. Falls has taken over the classes of Mrs. Dorris Stiles LaClasse, who was married several weeks ago and who is now living in Parish, N. Y. Mrs. Flynn is substituting for Miss Harriette N. Olin, who is ill.

Ice Carnival King, George McElroy, and Karma's "Empire Man," has been an active Teeber during his four years at Clarkson. In his freshman year he joined the radio club, the American Institute of Electrical Engineers, and the Karma fraternity. He acted as "Integrator" during his sophomore year. As a senior George served on the Board of Governors, became secretary of the A. I. E. E. and was also president of the Karma fraternity.

The crowning of Queen Elizabeth and King George is a fitting climax to their social life in Potsdam.

Yes, that's what all the girls will be wondering about 7:30 tomorrow night while hustling to get ready for the Snofesturized Ice Carnival Stag Dance.

Jack Meyers will swing out from 9:30 to 11:30 in the P. S. T. C. auditorium.

Camp Work Film Showing At Assembly

Dr. L. B. Sharp Will Show Film on Outdoor Recreation and Lead Discussions Throughout Day.

On Thursday, February 10, at 11:00 a. m., Dr. L. B. Sharp will lead an assembly on camping, when he will show a March of Time film on Camping Education. During the day, he will hold conferences with any of the students and faculty who are interested.

Dr. Sharp is a graduate of Eastern State Teachers College. He received his M. A. and Ph. D. from Columbia University. During World War I, he was a commissioned officer in the Navy. Since then, he has been connected with the Field Staff of the Nature Association, the University of Chicago, New York City Board of Education, and the U. S. Office of Education.

At present, Dr. Sharp is Executive Director of Life Camps, Inc. and instructor at New York University, School of Education.

In 1946, he founded National Camp, a graduate school for education in the out-of-doors. Besides a book "Education and the Summer Camp," he has published numerous articles in the general field of education and camping.

New Group

Students, Soldiers, and a Statue, Cast With a Chorus and Dancers in War Student Service Benefit Production.

"She can't be found
We've searched high and low,
But she's just not around.
The hall is empty
It's not the same"

These words will ring the rafters on February 16 in the auditorium when Rose Cawley as Athene, Sophia Constantikes as Melody, Pauline Desgagne as Felice, with the help of Leland Roberts as Izzie, Richard Switzercok as Chris, Warren Joseph, Jack Murray, Jack (soldier) Peter Barbaresci; a hostess, Patricia Chamberlain; Bobbie Munroe as Mac; and Agnes Hennessway and Lenore Mooney as Frosh, try to solve the mystery of Minnie's disappearance.

Large Chorus Assisting

The principals will be supported by a chorus consisting of Mary Lois Rudgers, Mary Ellen Argersinger, Eerlda Di Croce, Katie Fish, Anna Jones, Alyce Fraleigh, Wave Ninn, Elizabeth Brown, Joan Ellis, Marie Ryder, Lois Whitmarsh, Mary Elaine Shortsleeve, Kit Cornell, Athene Tsaref, Lenore Mooney, Dot Cuthburt, Jane Koehler; dancers, Martha Jane Hensley, Gretchen Klauey, Ward Berthold, Mareellus Rutledge, Dot Young, Lillian Warder, Eunice Reichert, Joan Ellis, Adrienne Moore, Sue Foley, Martha Minica, Marie Ryder, Alyce Fraleigh, Jane Cummins, Gladys Boynton, and Charlotte Tanner.

Soldiers Have Part

It has been announced by Miss Dora Dadmun, fine director, that some of the A. S. T. P. men will have a part also.

June Ebel and Mary Altomare have made the statuary for the sets.

"Missin' Minnie" is an original musical comedy written by the students and sponsored by the Blackfriar Society and War Council for the benefit of the World Student Service Fund. Tickets are on sale now and can be purchased from any member of the Blackfriars or War Council.

During World War II, many Potsdam Normal student organizations held fundraisers to benefit various war charities. The honorary dramatic society, Blackfriars, presented a musical comedy, *Missin' Minnie*, about the disappearance of the college's statue *Minerva*, affectionately called "Minnie." It was an original production written by students to benefit the World Student Service Fund.

At the intersection of Main and Market Streets in Potsdam is a lovely park on the banks of the Racquette River. In times past, this park was bordered on the other side by Water Street. Students of that era will remember the bowling alley and the bus station there. A memorial plaque in the park reads, "Ives Parkway, given in memory of Hon. M.V. Ives, by his brother H.L. Ives, 1932."

Three

EVENTS OF THE
NORMAL SCHOOL DAYS

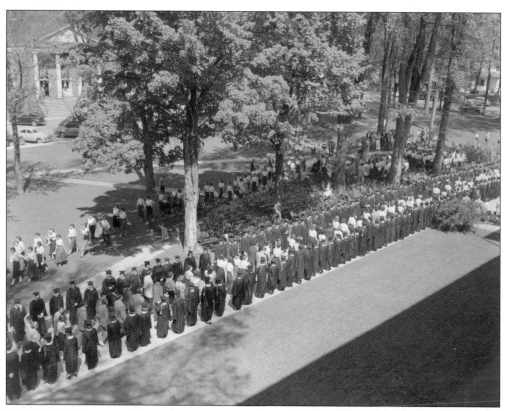

Moving-Up Day was a traditional ceremony held for a number of years prior to commencement. Students symbolically advanced one year to their forthcoming status, and freshmen also took off their caps and armbands. It represented the turning over of duties and positions from current seniors to the junior class, who would become seniors. This Moving-Up Day ceremony from 1929 shows junior students processing through the outer lines of seniors.

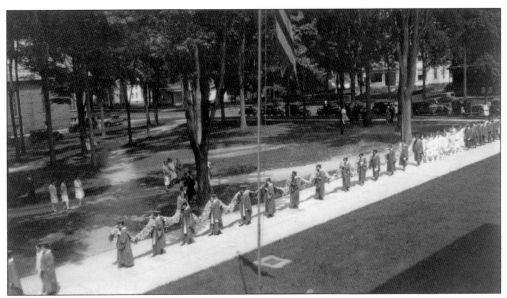

Class day ceremonies also occurred prior to commencement and included a procession with honor students leading the way. The line of students proceeded through all the halls of the Potsdam Normal School, as well as outside, with all singing as they went.

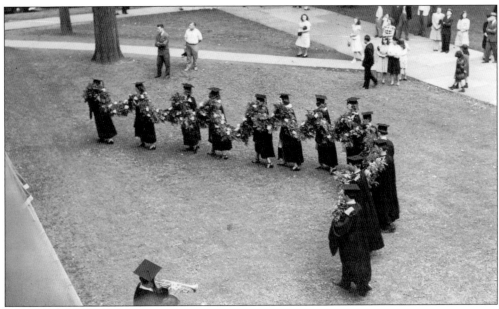

The tradition of the daisy chain was part of the class day procession and was carried by the honors students. In the earliest years, an ivy chain was used instead. The first daisy chain was made by the juniors in 1919. The practice lasted through the 1930s and 1940s.

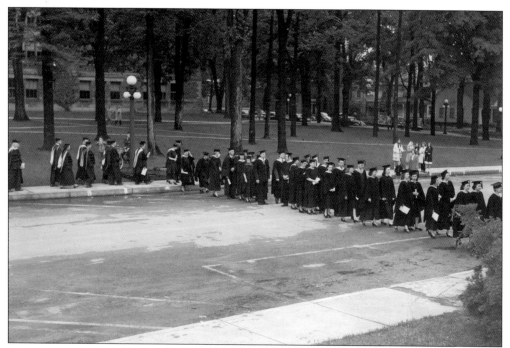

Commencement ceremonies have been a significant event for students and their families alike through all the years of the college. In earlier years, as seen in this photograph, the faculty and students proceeded from the Potsdam Normal School building across the street to the Potsdam Civic Center. As the size of graduating classes increased, finding spaces large enough for commencement became a problem.

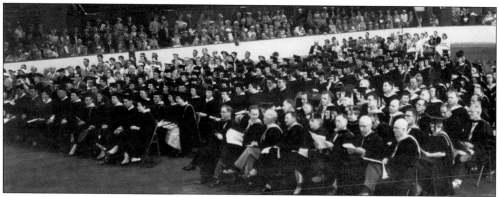

The location of the commencement ceremony has varied a great deal over the years, with some ceremonies taking place outdoors. This indoor ceremony from 1956 took place in Clarkson's Walker Arena because the space needed for the ceremony grew beyond the size of any available indoor capacity on the college's own campus.

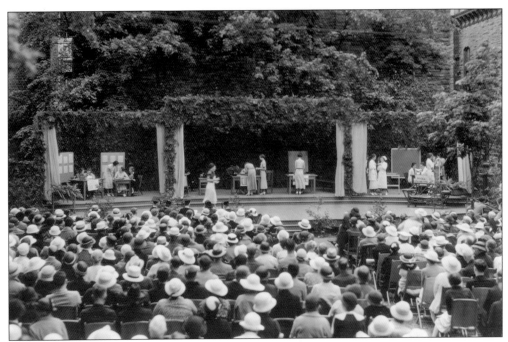

The 100th commencement in 1934 was a special celebration with extra activities marking the milestone. As part of the festivities, a dramatic production that used three different stages specially constructed outdoors was presented. Creative works such as music, narration, poetry, and dance were all written for the special celebration.

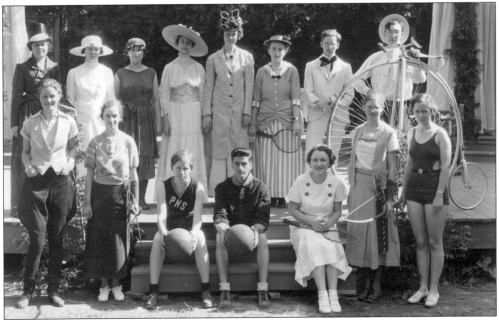

Also included in the special festivities for the 100th commencement was a pageant depicting the evolution of sports costumes from 1834 to 1934. Here, students who participated in the pageant pose in their costumes with an old-time bicycle. The bicycle might have just been a prop, or perhaps one of the students actually rode it as part of the pageant.

38

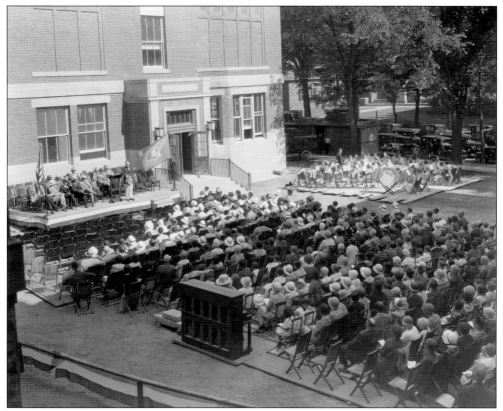

This unspecified ceremony is being held outside the Congdon Campus School. The presence of the music education major at the college provides the wonderful benefit of live music for many events for the campus as a whole. Here, the band waits patiently to play, and a piano has been rolled outside to use for the musical portions of the event.

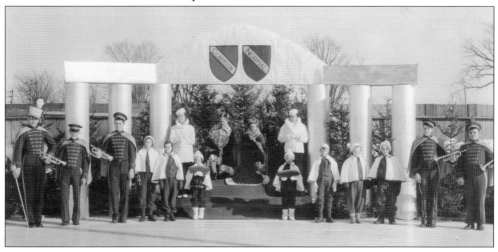

To help make it through the long winters as well as the Great Depression, the popular annual tradition of the Winter Carnival (later renamed Ice Carnival) was initiated in 1931 by the Potsdam Normal School and Clarkson College, also in Potsdam. For many of the years, a king and queen were chosen, and they can be seen here with members of their court and others.

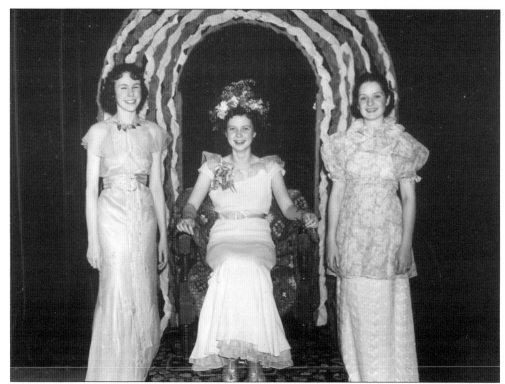

The tradition of queens was clearly very popular during particular time periods of the college's history. In addition to the Winter Carnival, another queen was selected later in the spring for the May Day event, as depicted here in this 1937 photograph. Various May Day events occurred in different years, including a YWCA May Day breakfast.

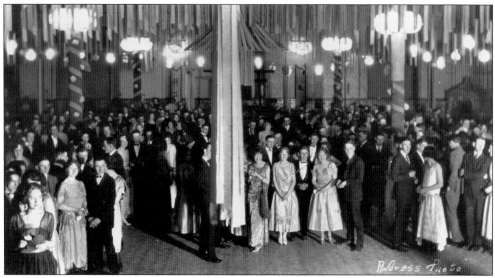

Although the music and dance forms have changed over time, dances have been an important event during much of the college's history. This photograph shows a student dance from the 1930s, which appears to have taken place in the Potsdam Normal School gymnasium. Decorations for the dances were oftentimes quite elaborate. (Photograph by Andress.)

Teas were also an important event in earlier years. A samovar that was believed to have been purchased in the 1930s was used for all of the teas and other special social occasions. The dean of women, Dr. Patience Haggard, frequently had the samovar in her office in the 1940s and 1950s.

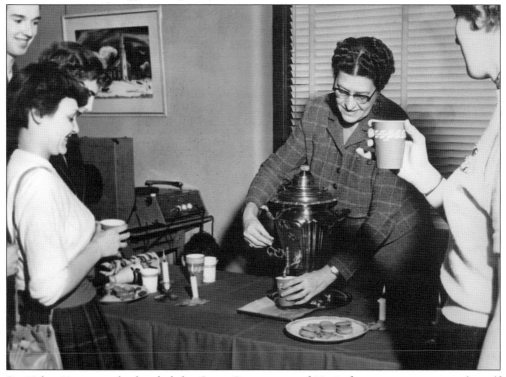

Dr. Helen Hosmer, who headed the Crane Department of Music for many years, pours herself some tea as she enjoys time with students. The samovar was particularly important since it signified the special bond between students and faculty at the college. It is still owned by the college and now has a permanent home in the College Archives and Special Collections.

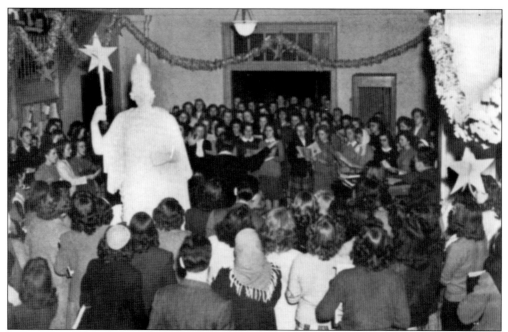

A yearly gathering during the Christmas season was looked forward to by all. Even once the school had changed names, the celebration was always in the lobby of the main building of the college. That area was completely decorated, and much singing ensued by the students. This 1945 view shows *Minerva* guiding the way with her star.

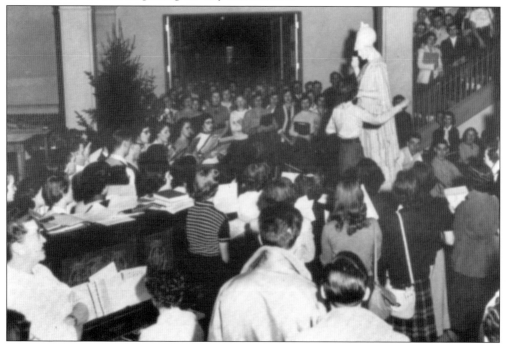

The 1953 usual Christmas gathering still shows *Minerva* participating in the festivities in the same location. Dr. Helen Hosmer, lower left, looks on as the students sing joyously. This probably was one of the last times that this building was used for the Christmas gathering.

Four

MOVING FORWARD AS POTSDAM STATE TEACHERS COLLEGE AND SUNY

The earliest yearbook, *Souvenir of the Graduating Class*, dates to 1897 in the College Archives. In 1916, personalized velvet-covered editions were given to the graduates. The yearbook would be known as the *Senior Class Book* in 1919, *The Annual* by 1925, and by 1927 *The Pioneer*. The 1925 edition of *The Annual* was the first to devote space to an individual description and photograph of each graduate.

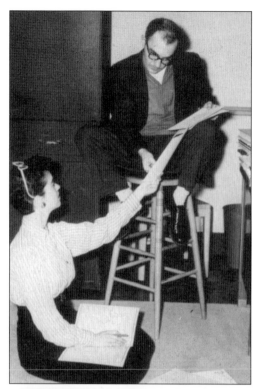

Editor Julie Eisenstein and faculty adviser James F. Warwick are shown here working on the 1957 *Pioneer*, which took first place in a contest sponsored by Pi Delta Epsilon, the national journalism fraternity. The judging was based on the arrangement of pictures; cover design, typography, and overall excellence. The *Pioneer* competed against more than 150 other yearbooks submitted by colleges throughout the country with enrollments from 600 to 1,400 students.

The Racquette, Potsdam's student-run newspaper, was published for the first time on April 2, 1927, under the name *The Normal Racquette*. It was created, in part, as an avenue for members of the student body to express freely their thoughts, ideas, and opinions. Students who work on the newspaper gain valuable experience and have the opportunity to have their writings published.

Harriet Crane Bryant, music faculty member and strong supporter of the newspaper, wrote the first letter to the editor. She praised the students for their efforts and reminded them, "Broader minds, in all matters, are what we all need to cultivate." For more than 80 years, *The Racquette* has been constantly striving to be an ideal in representing Potsdam's student life and opinions.

The Verse Speaking Choir was a student-run organization dedicated to fostering appreciation for rhythm, poetry, and the beauty of the English language. The choir performed plays and poetry readings and also participated in the Moving-Up Day pageant, creating a background for the narrator. The club was started in the fall of 1940. Unfortunately, it appears to have been active for only a few years.

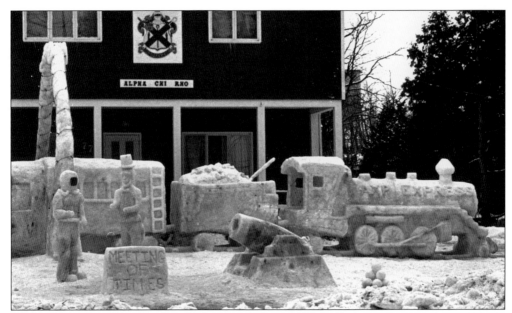

The construction of ice statues was a significant element of the Ice Carnival; they were located in various places around the village, including Greek houses. Much skill was developed in their construction. February temperatures were usually very cold, the air dry, and the snow light and fluffy. Water and heat had to be used in varying amounts and degrees to get the snow to pack.

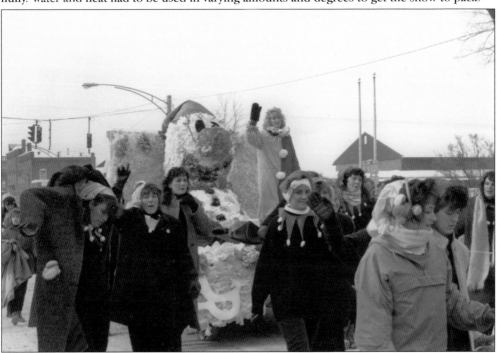

Early Winter and Ice Carnivals featured an ice show by a professional skating club from Ottawa and barrel jumping by athletes from Lake Placid. Students participated in activities and contests for skating, skiing, and tobogganing. There were also a costume contest and formal dance. This clown-themed float is part of a parade through the village streets.

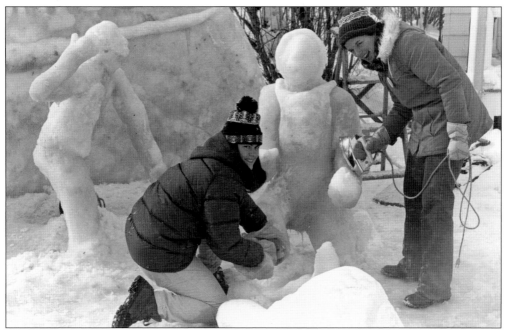

There were strict rules for constructing an ice statue. It was required to be a freestanding structure completely isolated from any exterior physical supporting device and was to be covered by at least one-quarter inch of ice. Mechanical devices, colored lights, and paint were allowed. This rule was designed to allow enhancements to statues.

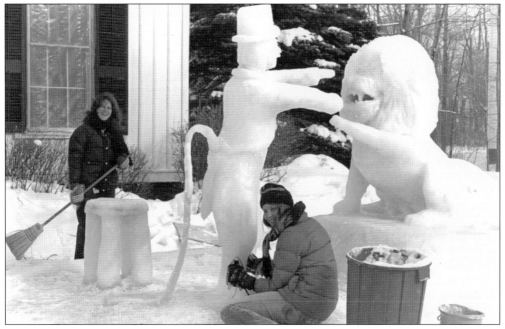

There was a statue competition among the fraternities and sororities of Potsdam and Clarkson. Independent groups competed among themselves. Statues were judged on originality, theme, skill or design, and execution. They were judged once in the daytime and once at night. In this photograph, two students are working on their rendition of *The Lion and the Lion Tamer*.

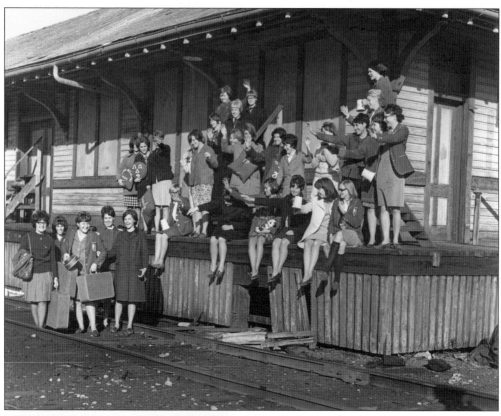

These sorority girls are at the old train station in Potsdam. Passenger service here ceased in the early 1960s. More that 15 years later when the Potsdam Relief Route (Sandstone Drive) was constructed, the old sandstone depot was slated to be demolished, but because of public outcry, it was saved by moving it a little to the east.

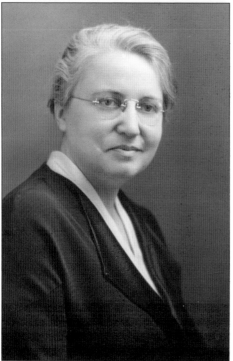

Dr. Patience Haggard was appointed to the staff in 1930 as professor and dean of women, positions she held until 1948. She then began teaching English full-time. Haggard, along with Helen Hosmer, was instrumental in organizing the Expression in the Arts course, with its emphasis on humanities and the interrelationship of the arts. This was initiated in 1947 and involved members of the art, English, and music departments.

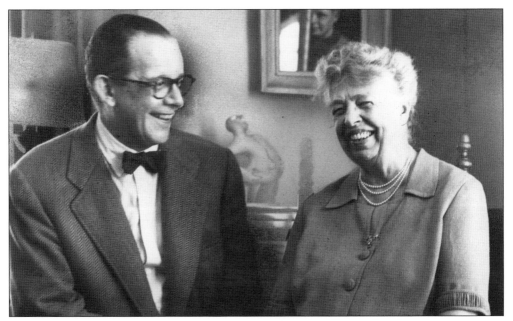

The early years of the Spring Festival, first held in 1932, were a Crane event and focused on music, featuring world-famous conductors such as Nadia Boulanger and Robert Shaw. In 1953, under the leadership of Pres. Frederick Crumb, the festival expanded to an all-college event and included (among other things) dramatic productions, artwork, films, dance, and guest speakers. Eleanor Roosevelt is shown here conversing with Crumb.

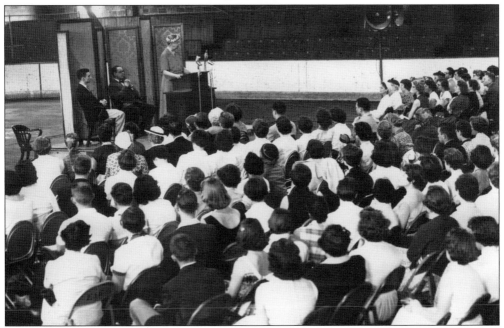

One of the festival's most eminent lecturers was former first lady Eleanor Roosevelt. She is featured in this photograph speaking at Clarkson's Walker Arena during the Festival of the Arts in 1955. In *My Day*, her syndicated column, she praised the college's program in the arts and remarked that real appreciation of the arts was going forward at Potsdam.

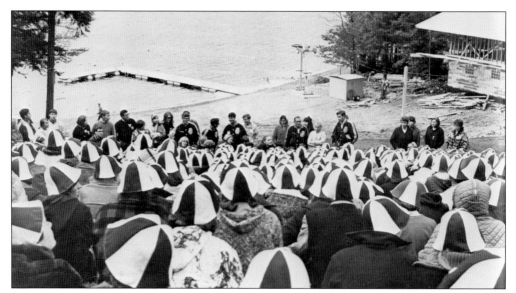

The college's Star Lake Campus is the setting for this "sea of beanies" worn by freshmen students in the late 1960s. Freshmen were required to wear a beanie at all times during their first months on campus. The beanie tradition was dropped in the early 1970s and thus is a foreign notion to students attending the college in the time since.

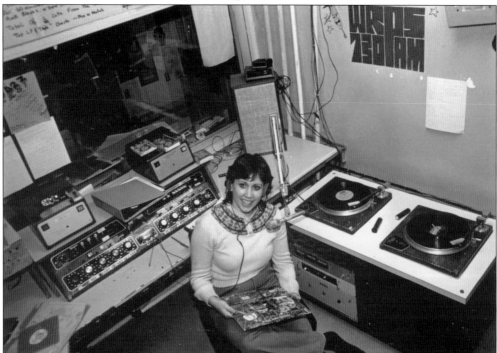

Inter College Radio Network (ICRN) and Northern Twin Colleges (WNTC) began in 1947, jointly owned by SUNY Potsdam and Clarkson. WRPS was formed at SUNY in 1967. Broadcasting was listed as rock music, campus events, guest speakers, and sporting events. During the 1980s, WRPS became an FM cable station. Pictured here is Kathleen Coffey (class of 1982), disc jockey and director of news. Later, the station changed its call letters to WAIH-FM.

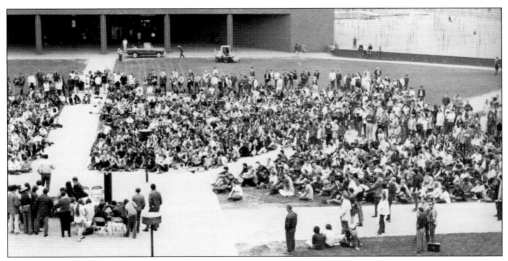

Potsdam students have shown their concern for political issues by staging protests such as this one held during the Vietnam War era. Classes were cancelled, and hundreds of students staged a strike. They are shown here gathered on the lawn of the main campus quad in front of Crumb Library.

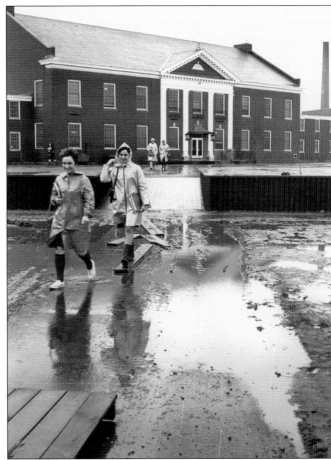

During the years of constant construction on campus, one could always find a muddy walkway. It was particularly difficult to maneuver around campus during the spring rains, which were referred to as "mud season." Here, two students are coming from Carson Hall on a rainy walkway fitted with planks for crossing the puddles. Until about 1977, Carson was known as the Student Union.

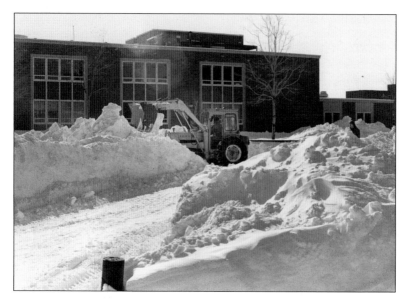

A member of the grounds crew is working hard to keep the walkways passable. Since snow will usually fall at any time, or all of the time, between October and May, the accumulation can get quite high, and frequent plowing is necessary. The Stowell Hall science building is in the background.

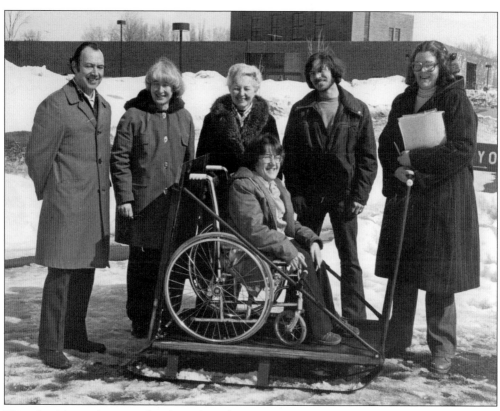

This wheelchair adaptation for class of 1976 graduate Denise Ann Schraden was built by Robert Mero, technical assistant for the Crane School of Music, with assistance from the custodial staff. Also pictured, from left to right, are Mero; C. Kelley, affirmative action officer; Marge Walawender, dean of student development and initiator of the idea for the sled; unidentified member of the custodial staff; and Marie Zimmerman, attendant for Schraden.

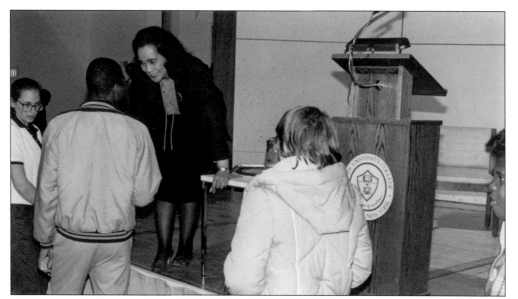

Coretta Scott King, wife of Martin Luther King Jr. and founding president of the Martin Luther King Jr. Center for Nonviolent Social Change, visited the campus on April 17, 1984, at the spring convocation. She advocated for nonviolence, for social, economic, and political justice, and for youth to get involved in politics. King spoke in Hosmer Hall, and Dean Hutchinson presented her with a recording of Crane Chorus.

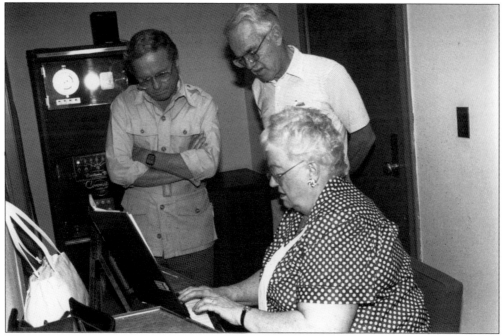

There have been two electronic carillons on campus. The first is thought to have been installed about 1954 when Raymond Hall (now Satterlee Hall) was completed and opened. It was a Schulmerich "Coronation" Carillon made by Schulmerich Carillons Inc., in Pennsylvania. Here, Helen King plays the keyboard of the first carillon while Crane colleagues and composers Robert Washburn (left) and Arthur Frackenpohl observe. The controller unit is in the background.

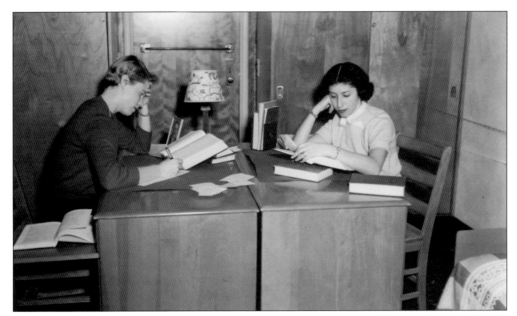

In the mid-1950s, the dormitory rooms in Morey and MacVicar Halls were for two female students. Each student was provided with a bed, desk, and chair. A wardrobe, with two sliding doors, can be seen in the back right, with an area for hanging garments on one side and drawers with mirror on the other. Each floor of the residential hall had only one coin-operated telephone, and there were no phones in each room.

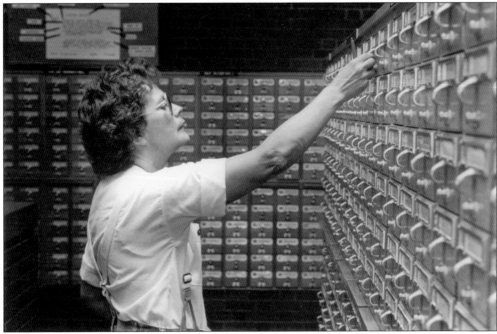

One of the least visible but very important services offered by the library is the prompt and intelligent organization and indexing of materials. Good cataloging allows patrons to retrieve materials quickly. Advances in technology have made this card catalog obsolete. (Photograph by Nancie Battaglia.)

Five

THE NEW CAMPUS AND ITS EXPANSION

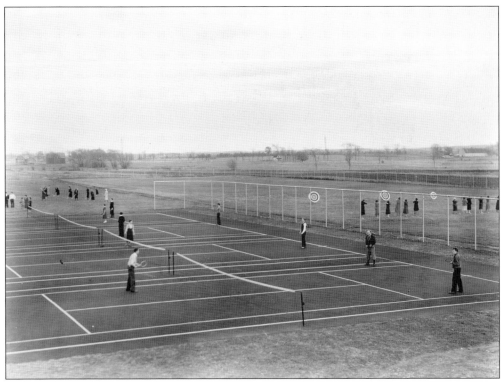

Long before a new campus was begun on Pierrepont Avenue, the college bought the property. Different parcels comprising 10 acres were purchased in 1936, with the land used for sports purposes only. Named Congdon Field in honor of Randolf Congdon for his efforts in achieving the purchase, it was used for such sports as archery, tennis, and field hockey, as seen here. An additional adjacent 25 acres were acquired in 1944.

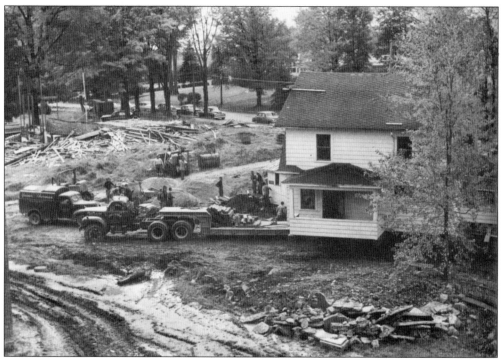

No information exists to indicate whether or not the college planned to actually relocate the entire campus in the future when it purchased the Pierrepont Avenue land for sports fields. But as space ran out for expanding programs and enrollment, it was determined at some point to make the move to the new location. This involved not only the construction of a number of new buildings, but also moving existing structures on the land to vacant lots nearby. Here, one such house is being prepared for its change of address, and a garage is lifted with a large crane.

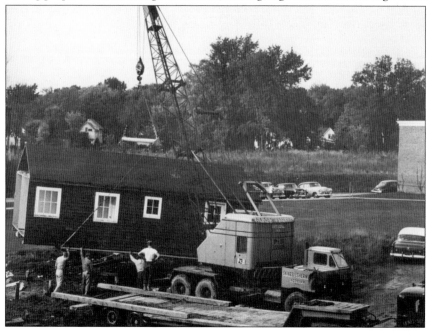

Merritt Hall was one of the first four buildings constructed at the new campus in 1951. It originally housed the physical education department and some dance studios. Its gymnasium was home to different athletics and physical education classes. Both the old gymnasium and old pool in Merritt Hall are still athletic and swimming purposed, while the rest of the building has been altered to serve other functions. (Photograph by Laird Chaffee.)

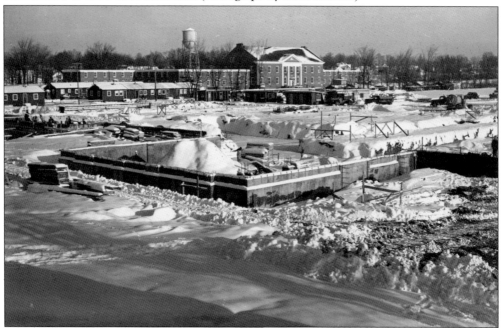

Satterlee Hall was originally called Raymond Hall. The name was changed when the new administration building was constructed, with the Raymond name transferred to the new structure and this hall renamed Satterlee. The building took some time to complete and was finished in 1954. This early view of its construction from 1951 shows the foundations partially completed.

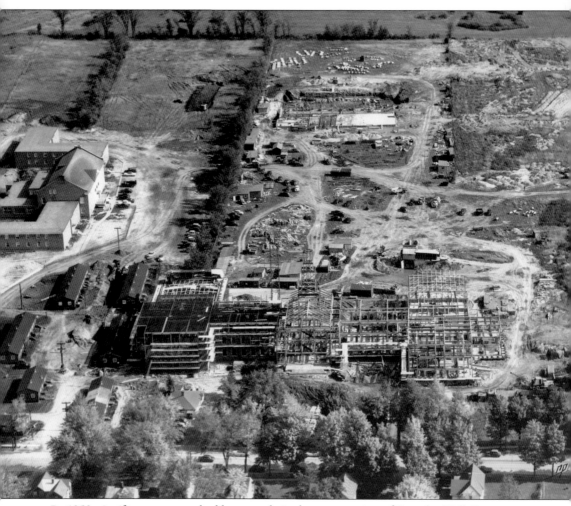

By 1952, significant progress had been made in the construction of Satterlee Hall. Because some buildings were already open on the new campus, parts of both campuses were used during this time period, and the locations were close enough for easy walking distance between the two. Satterlee Hall originally housed the college administration and all of the classrooms for the campus when it first opened. All academic disciplines were located in the structure, with plenty of space to spare at that point in time. With all classes in one building, students frequently crossed paths with all their peers. The new library was also located in the building and provided much additional space for both studying and collections with its basement stacks area and two upper floors. As the number of attendees and programs kept expanding, the college gradually outgrew the space available in Satterlee Hall. Planning then began for a major expansion of the campus.

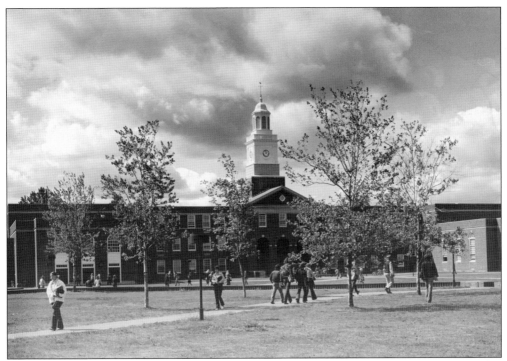

Satterlee Hall is still a well-known edifice to graduates of the college. In addition to housing several academic departments, including the School of Education and Professional Studies, the building contains a newly revamped Sheard Literacy Center and a permanent exhibit on the history of the college, located in the Mary E. English Commons.

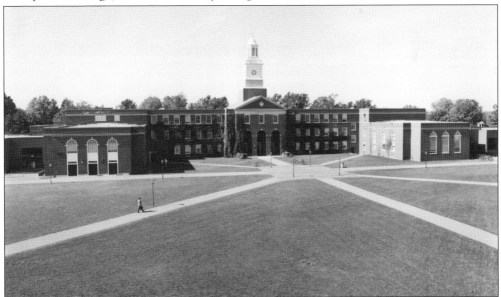

This view of Satterlee Hall shows part of the extensive grass area of the academic quad. Also seen are the outer walls of the old College Theatre to the left and the portion of what had been the old library, now used for the Sheard Literacy Center, on the right. Sculptures are also located in the quad, and it is regularly used for other events and activities.

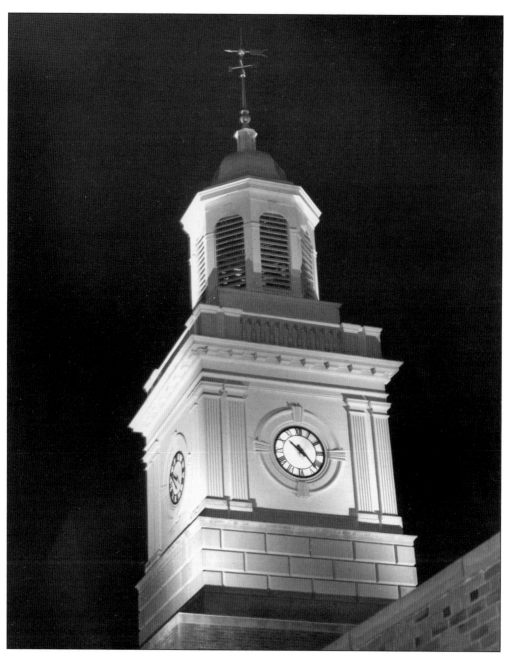

The clock tower on the present Satterlee Hall has been the main symbol of the campus since it was first constructed. It has been the first and only clock tower for the college, and an artistic rendition is used on all campus publications and official stationery as well as everywhere on the school's online presence. When the clock tower was renovated a few years ago and the original faces were removed, one clock face with hands was thankfully saved; it now has a wonderful home for all to see in the Mary E. English Commons as part of the permanent exhibit on the history of the college. The clock tower has been a familiar sight to many generations of students, and the sound of the carillon is both a memorable and enjoyable aspect of each student's time at Potsdam as well.

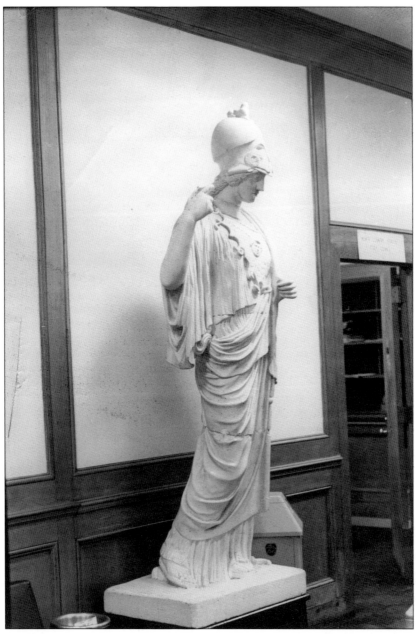

Minerva meandered up to the new campus from her downtown location as well, although it is not known what mode of transportation she used. She was happily stationed in Satterlee Hall for many years until she was involved in an unfortunate accident and badly damaged. Students and faculty alike were dismayed to find that she had toppled over and was lying in pieces on the floor. Because of their fondness for *Minerva* during their years at the college, alumni provided donations for her repair. Both faculty and students from the art department provided many hours of hard work to restore her. Beautifully healed through their careful work, *Minerva* was ready to make her reappearance on campus. She was then moved to the Crumb Library lobby, where she could be seen by all more easily from her new location in the middle of the quad. (Photograph by William N. Swift.)

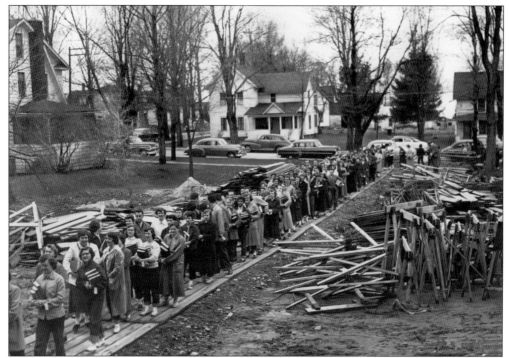

Total campus participation in helping move the main library from one location to the next has been a tradition on the campus. Students and faculty form a human chain to move books here during the first "Booklift" move from the old downtown campus to the new library in Raymond Hall (now Satterlee Hall) on the Pierrepont campus in May 1954.

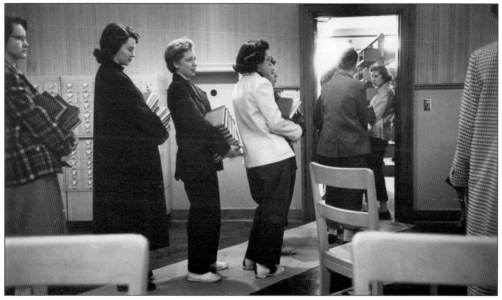

Once inside, students entered the new library area. When each student reached the appropriate stacks area, he or she handed a pile of books to a library staff member who shelved them. A numbering system was used so that each load of books for each student could be placed in proper call number order. (Photograph by Yale Joel.)

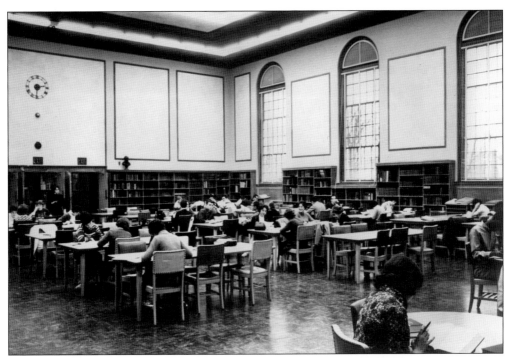

The inside of the older library housed in Raymond Hall (now Satterlee Hall) is a familiar sight to many graduates, who spent a great deal of time in this library. The Palladian windows continue to be a familiar sight on campus. This portion of the former library now houses the Sheard Literacy Center—an appropriate use given its historical role in earlier years.

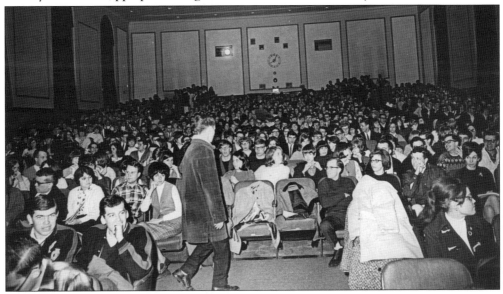

Satterlee Hall's College Theatre was the site of musical and dramatic performances. When it opened in the 1950s, it was one of the best-equipped theaters in the northern part of the state and seated 800. Later, when other larger halls were constructed specifically for musical performances and productions, the College Theatre was divided into two spaces for dramatic productions, one a black box theater. (Photograph by Laird Chaffee.)

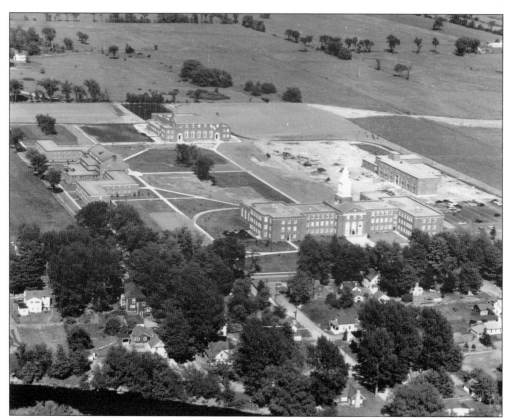

Aerial views of the Pierrepont campus in different years provide an excellent glimpse of the changing nature and growth of the college. In this view from 1957 or so, only six buildings existed on campus: College Union (now called Carson Hall), Morey Hall and MacVicar Hall (both used as residence halls at that time), Merritt Hall, Raymond Hall (now Satterlee Hall), and Crane Hall (used for the music department).

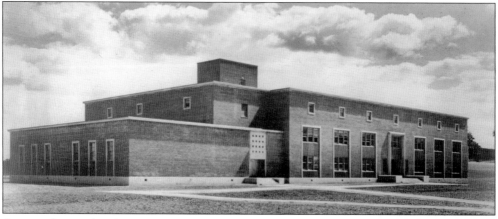

Crane Hall, completed in 1957, was considered a state-of-the-art music facility at the time. It had been carefully planned in terms of practice rooms, studios, classrooms, rehearsal rooms, recital hall with new organ, lobby for receptions, and music library. When the Crane School of Music outgrew the space and a new music complex was built, Crane Hall became Dunn Hall, housing several academic departments from the School of Arts and Sciences.

This aerial view from 1958 shows the same buildings, with a wider view of the surrounding area, including farms visible at the time next to campus. An eatery known to the students as the "Dairy Bar" was a favorite spot for refreshments. One large boulder, now located on campus at Lehman Hall, graced its entrance. It did not take long for students to feel as if they were out in the rural area.

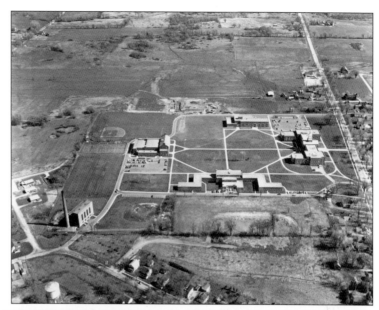

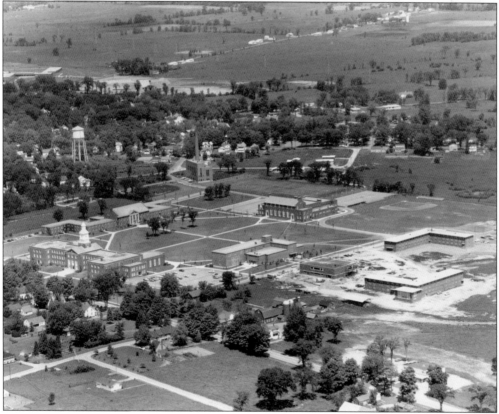

As time went on, the campus began to construct additional new buildings to meet the demands of its expanding enrollment and programs. Used as residence halls, Sisson Hall and Van Housen Hall are now evident in this 1960 aerial view, and the new dining facility named Thatcher Hall had also been constructed. (Photograph by Dwight Church.)

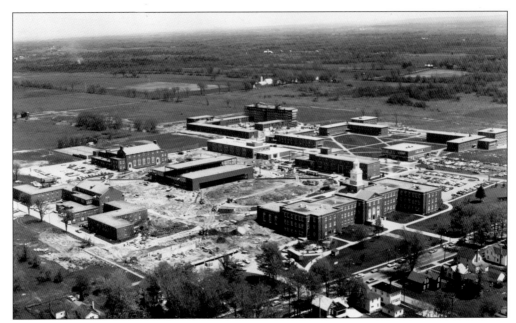

Taken in 1966, this aerial view shows two additional residence halls, Draime Hall and Knowles Hall, and a new science building named Stowell Hall. A new library, to be named Crumb Library, was being built in the middle of the quad as a symbol of its importance to the academic mission of the college. (Photograph by Martin R. Wahl.)

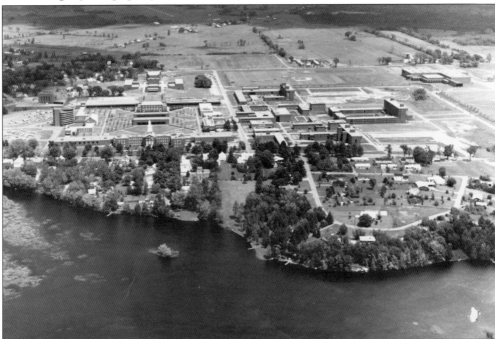

This similar aerial view of the campus shows one additional significant element of the college, the Racquette River. The college-owned land on its banks continues to be a wonderful location for social activities and athletic passions, including paddling on the waterway. The college's alma mater begins, "On the banks of Racquette River, with its hills of blue."

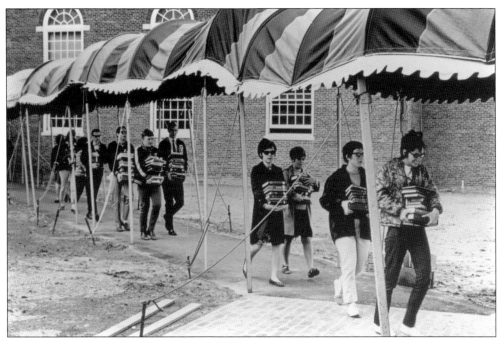

When the new library was completed in 1967, students and faculty again formed a human chain to carry all the materials by hand from the old library to the new, following the earlier established tradition. This time, the walk was much shorter, since the buildings were closer to each other, and a canopy provided protection from sun, wind, and rain as students and faculty carted piles of books across the academic quad to the new Crumb Library. For the first time on the campus, the library now had its own separate building. A video was also taken to provide the college a more "alive" view of the event. (Both photographs by Richard Bitely.)

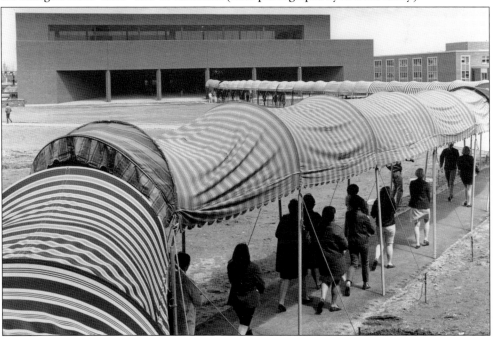

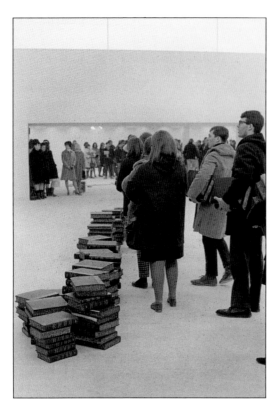

Once students and faculty arrived in the new library, staff placed each load of books into proper place on the shelves. The facility was named for Frederick W. Crumb, who served as president from 1946 until 1967. Given his many contributions during a time of great campus expansion, it was determined after his sudden death to name the library for him as a fitting tribute. (Photograph by Richard Bitely.)

While Crumb Library's lobby was being renovated, *Minerva* needed to temporarily move to a safer place, so she hitched a ride from a campus workman and his nifty machinery. She then moved to her permanent new spot in the library's Minerva's Café, where she continues to enjoy hobnobbing with students just as she has done at her different locations for many years of the college's history. (Photograph by Jane Subramanian.)

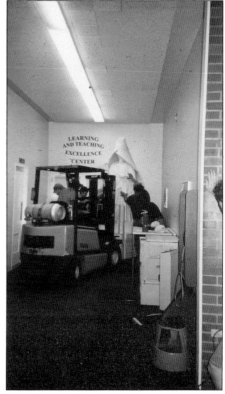

Six

THE BIRTHPLACE OF AMERICAN MUSIC EDUCATION

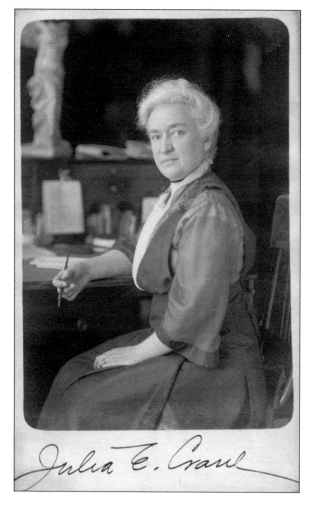

Julia E. Crane

Music in the public schools prior to the 1880s had always been taught by studio teachers or musicians trained at a conservatory. Julia E. Crane, a graduate of Potsdam Normal School in 1874, was a leader in recognizing that there was great need for specially trained music teachers in the public schools. In 1884, she was asked to join the faculty of her alma mater.

Julia Crane founded the first normal training course for public school music teachers in the United States. Soon afterward, she published the first edition of her *Music Teachers' Manual*, a complete system of music instruction for primary grades through normal schools. She published eight editions between 1887 and 1923. The principles of this manual are still used today for training music educators.

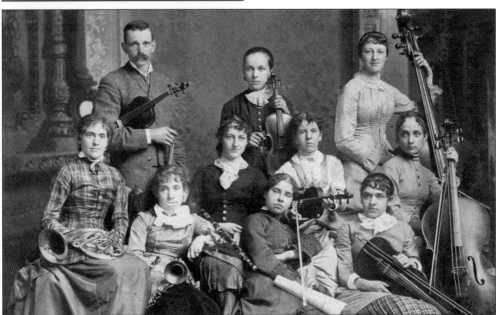

Jessie Crane (first row, right) and Harriet Crane (first row, second from left), sisters of Julia Crane, appear in this photograph of an orchestra from the 1800s. The first such musical group at the college began as early as 1879 under the leadership of Fred Harrington, and according to one researcher, only the orchestra at Harvard University preceded Potsdam Normal School's as a collegiate ensemble.

In the mid-1890s, Julia Crane purchased a house on Main Street next to the three-story Potsdam Normal Building. She had it remodeled and used the downstairs as her teaching studio and the upstairs as living quarters for herself and her sister Harriet Crane Bryant. This is a view of the house before any renovations or additions.

This c. 1905 photograph of the remodeled Crane Normal Institute also shows the addition of porches. This structure was one of five used between 1886 and the present to house the program of the Crane School of Music. In 1926, the Crane Normal Institute of Music was purchased by the State of New York and organized as the Crane Department of Music of the Normal School.

The music studio has been home to countless music students on campus from the days of the Crane Normal Institute of Music, to the Crane Department of Music, to the present Crane School of Music. Seen here in this c. 1900 photograph is the music studio of Julia Crane. It was located in the Crane Institute of Music house on Main Street.

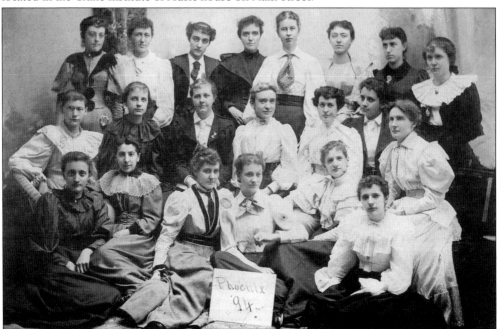

Phoenix Club is pictured here in 1894, the year of its founding. Julia Crane (second row, center) formed this select group of women's voices. Members were originally chosen from the senior class but were later selected from all classes. It is the oldest choral group on campus and the second oldest college women's choral ensemble in the country. Among its conductors have been Helen Hosmer and Mary English.

Harriet Crane Bryant graduated in 1885, ten years after her sister Julia. Harriet became her sister's assistant at Crane and remained there until 1931. She composed many solos for voice and piano. When there was a contest to write a new alma mater, she submitted an entry. However, the next day she submitted two additional compositions, explaining that it may be thought the first did not have sufficient dignity.

This 1910 photograph shows members of the Crane family posing on the porch steps of the remodeled Crane Institute. From left to right are Jessie Crane Moore (Mrs. Frank Moore), Daisy Crane Sisson (Mrs. Charles H. Sisson), Jerome Crane, Harriet Crane Bryant (Mrs. Willis Merton Bryant), and Julia E. Crane.

The Potsdam Normal School Orchestra of 1889, conducted by F.E. Hathorne (later changed to Hawthorne), is ready to perform on the stage in the chapel. At that time, Hathorne was in charge of the Normal Conservatory of Music and director of instrumental music at Potsdam Normal. By the early 1900s, there was reference to the Department of Instrumental Music.

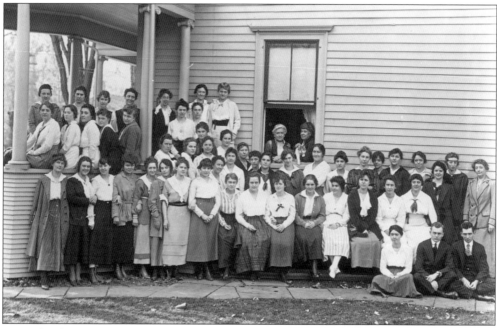

In 1886, Julia Crane incorporated the Crane Normal Institute of Music. This is considered the founding date of the present Crane School of Music. The class of 1918 is seen here assembled outside of the institute. In the window are Julia Crane (left) and her sister Harriet Crane Bryant. Helen Hosmer is standing to the right of Bryant.

The first organ for the music program, a four-manual pipe organ, was installed in the new normal school building. Frank Merrill Cram was the first organist. When he left Potsdam in 1925, Helen Hewitt (pictured) became organist. She had attended Vassar College and Eastman School of Music and had spent a summer at the American Conservatory in Fontainebleau, France. (Photograph by Clarence Premo.)

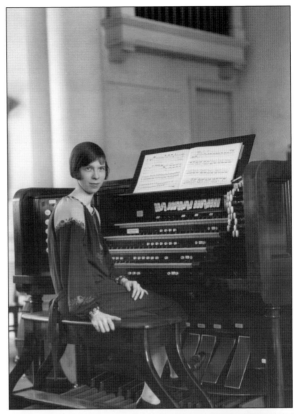

The Normal Choral Society, previously called the Special Music Chorus, was composed of students in the Special Music Teachers course and other students who met the requirements in voice and music reading. They are pictured here in 1926 performing their Christmas concert. Community choral singing became a regular feature of this holiday program. After the concert, many students went through town caroling at the homes of faculty members.

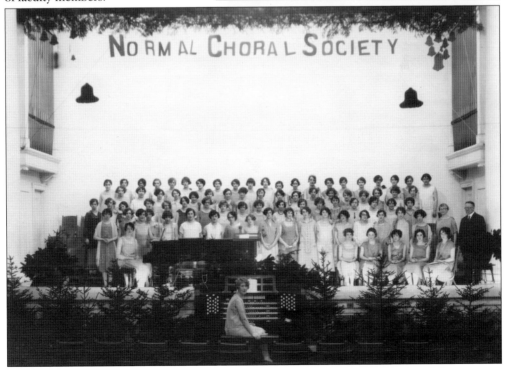

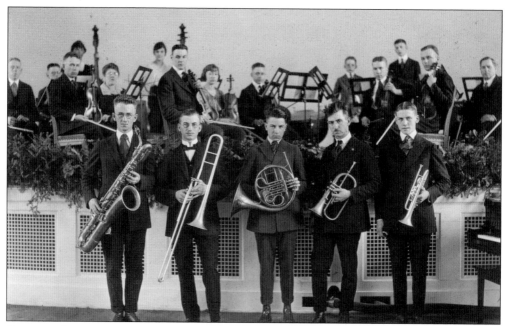

Crane graduates are thoroughly trained musicians with an emphasis on solo performance as well as in large and small ensembles, with experience in a wide variety of musical styles. This is balanced with knowledge of the theoretical and historical aspects of music and an understanding of the methods and art of teaching. Shown here is a small ensemble posing with the orchestra.

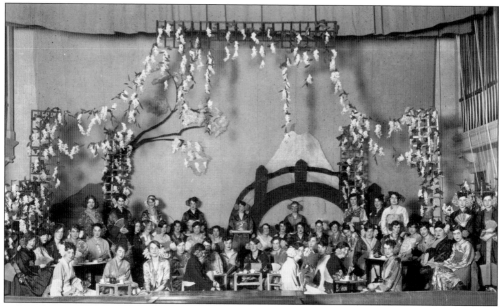

A production of the Japanese-themed operetta *The Last Tea of Tsuki* was performed in February 1930 by the Special Music students. The operetta is staged at a tea party. Guests are wearing colorful kimonos, and lavender wisteria hangs from the latticework. A Japanese-style bridge and two mountains are in the background scenery, painted by several of the senior girls.

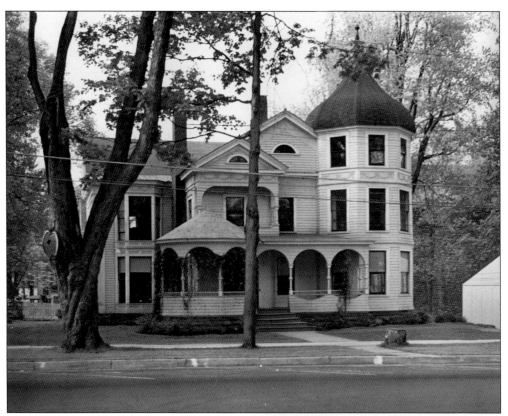

As the music program grew, so did its need for more space. In the early 1930s, the Grant property on Elm Street was purchased, and the house was converted to teaching studios and practice rooms for the Crane department. This facility continued in use until a new building was constructed on the Pierrepont Avenue campus.

Helen Hosmer graduated in 1918 from both the Normal Course for Classroom Teachers and the Crane Institute Course for Supervisors of Music. In 1922, she joined the Potsdam Normal faculty. She went to study at the American Conservatory in Fontainebleau, France, in the summer of 1925 and began a long and close friendship with Nadia Boulanger.

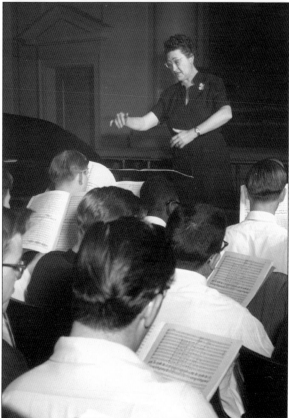

In 1927, Helen Hosmer began summer studies at Teachers College, Columbia University, earning advanced degrees. At Columbia, she worked with programs in integration of the arts. She used this arts approach in all of her teaching and ensured that the students of Crane had a firm foundation, with almost total immersion in all the arts. In 1930, Hosmer was appointed director of the Crane Department of Music.

Soon after she became director of the Crane Department of Music, Hosmer realized that classes had grown so large that some of the intimate feeling and personal touch was missing. She initiated a weekly "Crane Meeting" to foster the spirit of Crane. There were lectures and discussions, and to end each meeting, there was group singing. Crane Chorus was formed during these weekly sessions, and its first public concert was in 1932.

This 670-seat Potsdam Normal School auditorium was the venue for the first Spring Festival in 1932. It featured the recently formed Crane Chorus conducted by Helen Hosmer in a presentation of *Hiawatha's Wedding Feast* by Samuel Coleridge-Taylor. The chorus of student singers was augmented by talented vocalists from among the townspeople and faculty.

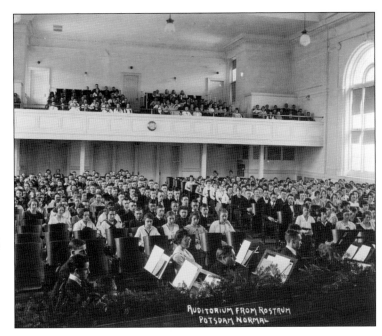

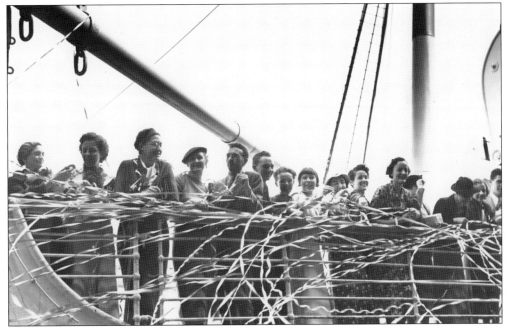

In August 1936, Helen Hosmer (third from left) led a student group in an experimental one-semester study abroad program to Germany, France, and the British Isles. Students had immersion in music and such disciplines as language, art, European history, literature, educational methods, and local culture. The experience provided them a richer background to become superior teachers. The group is seen here preparing to sail.

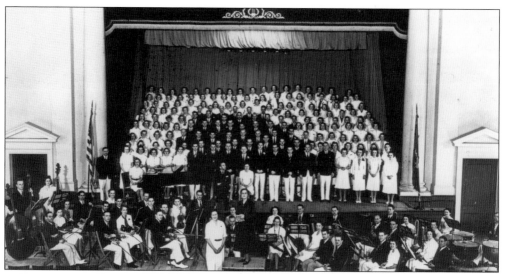

Helen Hosmer believed that performing choral music under the finest conductors was the best way to teach musicianship. In 1939, she invited noted French maestro Nadia Boulanger to be the first guest conductor. The performance was Brahms's *A German Requiem for Soloists, Chorus and Orchestra*, and thus began Potsdam's Spring Festival of the Arts. Hosmer (left) and Boulanger (right) are seen standing with the chorus and orchestra.

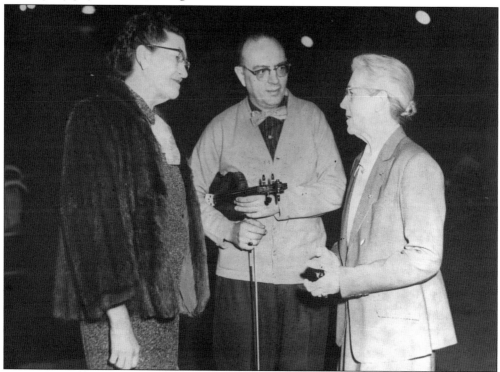

Seen here conversing after a performance are Helen Hosmer, director of Crane (left); Maurice Baritaud, orchestra director (center); and Nadia Boulanger, guest conductor. Weeks of preparation had trained the student musicians to be prepared to follow the wishes of the guest conductors and give immediate response to their directions.

80

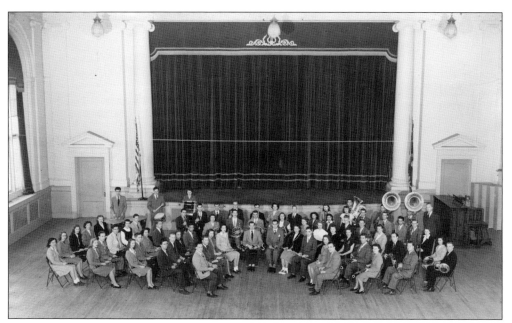

The Normal Band was organized in the early 1920s by James A. Garfield. He became its conductor in 1925 and was in that post in 1947 when this photograph was taken. This band was considered to have the more advanced players. Another band known as the Lab Band was composed largely of instrumental minors and conducted by Crane seniors.

Robert Shaw, posed here with Helen Hosmer, appeared as guest conductor of Crane Chorus and Orchestra 16 times between 1947 and 1980. This included Crane's participation in Shaw's Masterworks Series at Carnegie Hall in New York City. Shaw thought highly of Hosmer, as well as the programs and musical atmosphere at Potsdam.

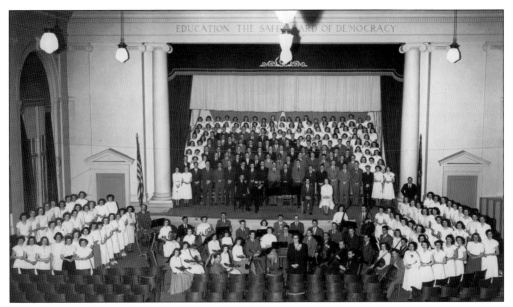

Between 1938 and 1958, Crane Chorus and Orchestra performed the *Requiem in D minor* by Gabriel Fauré six times. It was conducted three times by Nadia Boulanger and three times by Helen Hosmer. In a 1984 interview, Hosmer said that given her choice of compositions to conduct, her first choice would be Bach's *Mass in B minor* and her second would be the Fauré *Requiem*. Here, Hosmer poses with the group after a 1949 performance of the Fauré work.

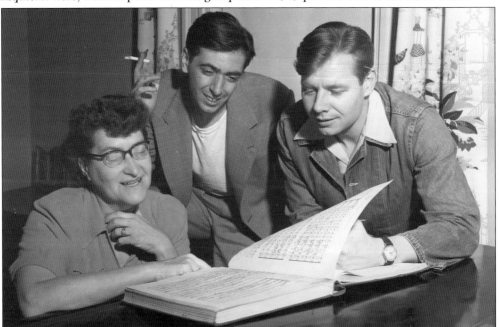

In 1950, Norman Dello Joio was commissioned by the college to compose a work for chorus and orchestra. His *A Psalm of David* was given its first performance at the Festival of the Arts in 1951 with Helen Hosmer conducting. This also marked the first time that any State University of New York campus commissioned a piece of music. The next evening, Robert Shaw conducted Bach's *The Passion According to St. John*.

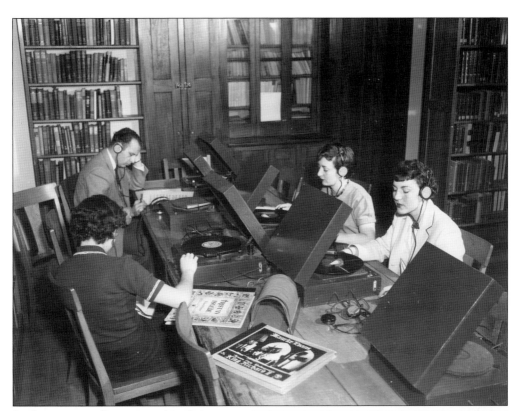

Students are totally engrossed in their assignments in the listening area of the Crane Music Library located in the second Potsdam Normal School building on the downtown campus. This photograph shows the library's "state-of-the-art" audio equipment of the times.

Crane music students spend many hours in the practice room perfecting music for their recitals and ensemble work. They also learn to play instruments that are unfamiliar to them. It is possible that this student chose to work in front of a mirror to make sure he used the proper embouchure for good tone production on his baritone horn.

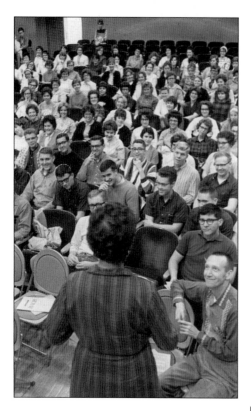

Helen Hosmer is seen here rehearsing with Crane Chorus in the recital hall of the Crane Hall building during the late 1950s or 1960s. Carl Druba (first row, far right), a 1948 graduate, was an assistant conductor during that time. All students in the music department, plus a few others by audition, were members of Crane Chorus, except students who performed with the chorus in the accompanying orchestra.

Ralph Wakefield graduated from Crane in 1942 and in 1951 returned as assistant to Helen Hosmer. Upon Hosmer's retirement in 1966, he became head of Crane and served as dean of music until retiring in 1976. He oversaw the establishment of the Departments of Music History and Theory, Composition, and Performance. Wakefield participated in the design and planning of Crane Hall and the Crane Music Center, which opened in 1973.

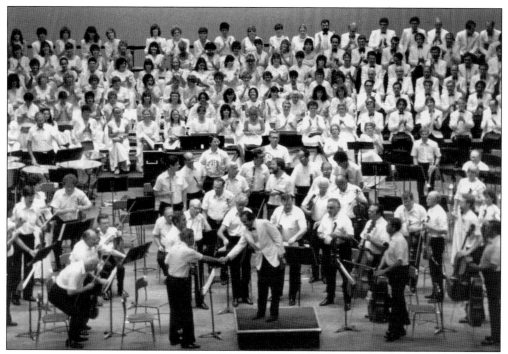

Crane was invited to create a summer music institute based at Skidmore College. The school provided a chorus to perform with the Philadelphia Orchestra under Eugene Ormandy at its summer home in Saratoga Springs. Prof. N. Brock McElheran directed the institute and prepared the chorus from its beginning in 1970 to its end in 1985. McElheran (on podium) is pictured shaking hands with the concertmaster after conducting a performance.

The entire music school helped prepare for Crane's performance at the opening ceremonies of the 1980 Winter Olympics in Lake Placid and also at events throughout the games. Crane provided a 600-member Olympic Chorus and Orchestra, 50-member Wind Ensemble, and three Olympic bands of 50 each. Class schedules were altered for the duration of the ceremonies and the weeks before for preparation.

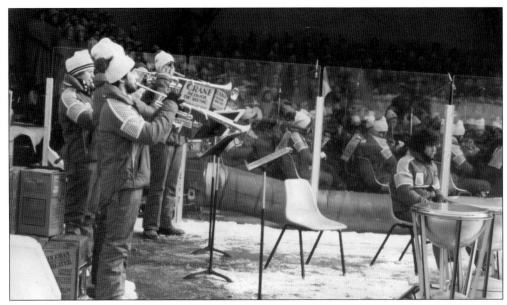

Students and faculty composed and performed original music for the 1980 Winter Olympics. They played national anthems at awards ceremonies and performed for both opening and closing ceremonies. Brass players were concerned that their valve oil would not be effective outside in such cold weather, so a local grocery store allowed them to experiment in their meat freezer. Shown here are the fanfare trumpets with Crane School banners.

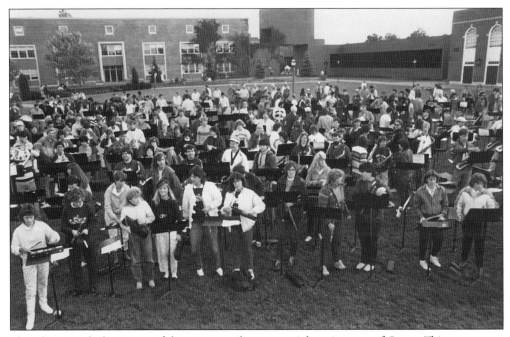

This photograph shows one of the events in the centennial anniversary of Crane. This was a year-long celebration of the founding of the Crane School of Music featuring commissions by faculty composers. On September 4, 1986, one thousand people gathered with their instruments in a massed band to play marches, show tunes, popular melodies, and special fanfares.

Crane School of Music's renown resulted in the invitation for Crane Chorus to perform at the unveiling of the refurbished Statue of Liberty on July 3, 1986. The event included many important dignitaries, and thus it provided strong visibility for Crane. This photograph shows the chorus behind Pres. Ronald Reagan at the ceremonies.

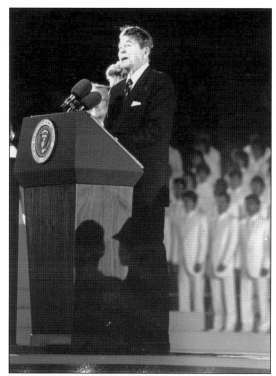

The Liberty Celebration Chorus was made up primarily of members of Crane Chorus and the Saratoga-Potsdam Institute. Three months later, the chorus performed with the New York Philharmonic in the world premiere of William Schuman's *On Freedom's Ground*. This was a historic part of Crane's centennial year celebration as well as the continued celebration of the 100th anniversary of the Statue of Liberty.

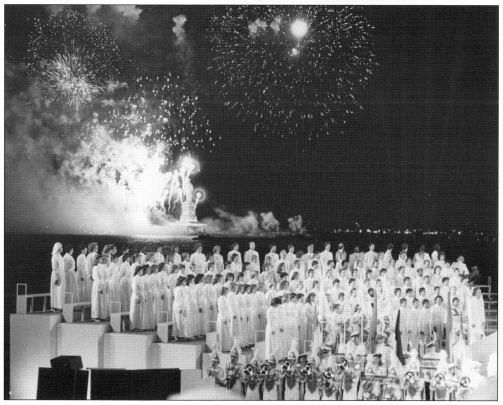

Crane hosted the 20th Annual International Horn Workshop in June 1988. Hundreds of the finest horn players from throughout the world assembled to participate in recitals, lectures, and clinics. Here, more than a dozen Alpine horn players give a concert on the lawn before an audience of workshop participants and local residents curious to hear the sounds of the up-to-14-foot-long wooden horns.

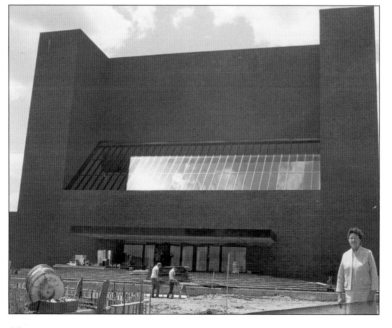

The Crane Music Center opened in 1973. Helen Hosmer here observes the construction of the building named in her honor, the Helen M. Hosmer Concert Hall. It was the first time any building within the State University of New York was named for a living person, a tribute to the esteem and affection in which she was held at home and throughout the state.

The Wicks Organ was installed in the new hall in 1977. An organ of this caliber in a concert hall the scale of Hosmer Hall is a rare combination that allows for many choral and orchestral masterworks to be performed as the composer intended them. The organ is also an integral part of the Potsdam tradition, as Hosmer's initials are incorporated into the design of the organ case.

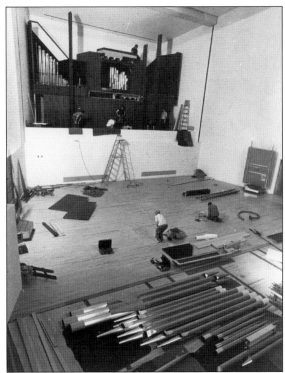

Representatives of the Wicks Organ Company of Highland, Illinois, are seen here erecting the framework to house the organ pipes. There were 38 sets of pipes for a total of nearly 2,200 pipes in all. Prof. James Autenrith presented a lecture-demonstration to introduce the new three-manual organ to the public.

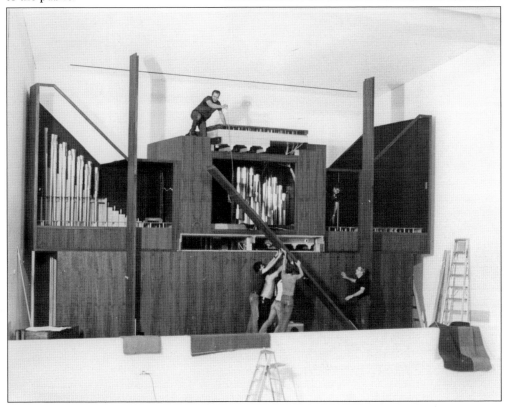

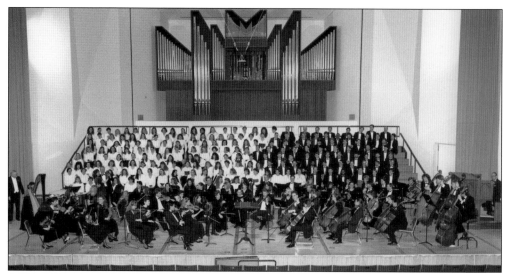

This photograph of Crane Chorus and Orchestra was taken after completion of the 1,400-seat Hosmer Concert Hall and installation of the organ. Other buildings of the music center include the 450-seat Snell Music Theater and Schuette and Bishop Halls, which have faculty and administrative offices, classrooms, and studios. Additionally, Schuette houses the extensive Crane Music Library, and Bishop has the more intimate Wakefield Lecture and Recital Hall.

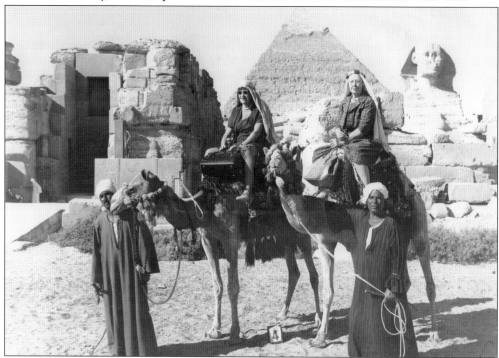

Helen Hosmer believed in engaging in each experience to the fullest extent, to be enjoyed and viewed at the time as truly important. She expressed this philosophy when she spoke to the Provincial Association of Protestant Teachers in Montreal: "I am an American and a modern educator who believes in experiencing, experimenting, and integrating experiences." Hosmer (left) and Jessie McNall, science department head, ride camels in Egypt.

Seven

A Long Tradition of Teacher Education

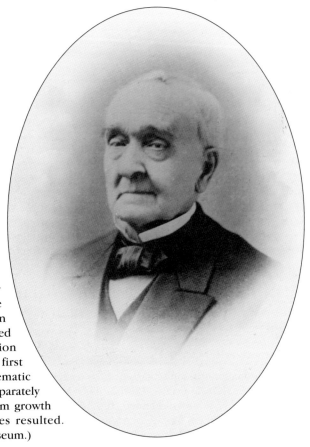

Asa Brainerd was hired as preceptor in 1828. His belief in the importance of raising the quality of education and teachers in district schools formed the basis of Potsdam's long tradition of teacher education. He was the first in New York State to make a systematic attempt to classify teacher training separately from other courses. Further program growth and high demand for its graduates resulted. (Courtesy of the Potsdam Public Museum.)

Beginning in the 1800s until the early 1900s, public school–aged children attended class at the School of Practice, also known as the Training School, in a building called the Stowell Annex. Here, children play outside the Stowell Annex with some snow still remaining, with the North Country area of New York State known for the late arrival of spring.

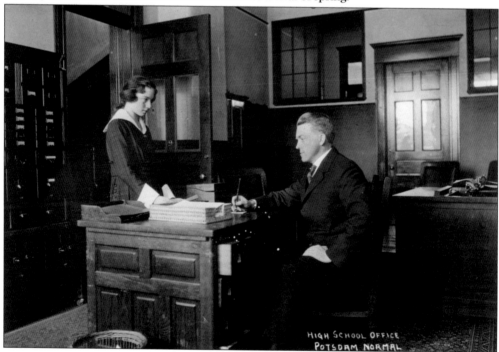

HIGH SCHOOL OFFICE
POTSDAM NORMAL

Faculty gather in the high school office during the time when the School of Practice still contained high school grades. This photograph is thought to be from the early 1900s, when the Potsdam Normal School contained three departments: the Normal Department, the Training School, and the High School Department. A separate public high school was later built in Potsdam, resulting in the dropping of those grades from the Practice School.

As the need for more space developed, a new building named Congdon Campus School was constructed and opened in 1931. An article at the time indicated that it was expected to enroll 800 students from kindergarten through eighth grade. This is a nighttime view of the entrance to the school.

Inside the Congdon School, this primary-grade classroom shows the teacher assisting one of the students with a model of a house. The other students in the class are working hard individually with their seat work and are sitting quietly in small groups at their desks.

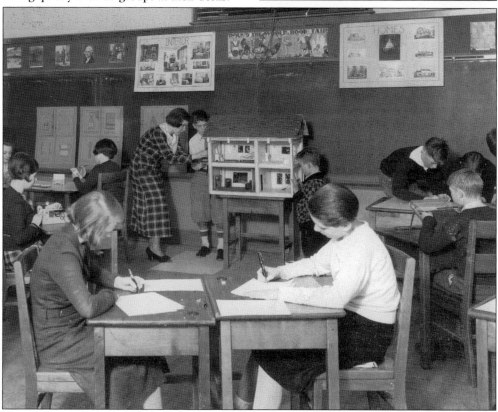

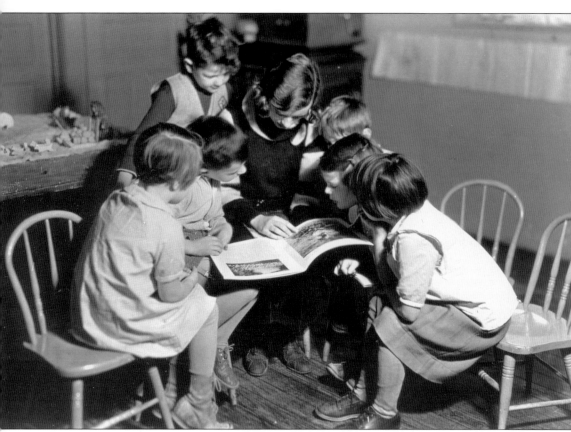

The Practice School and campus school consisted of primary grades and were designed to afford teachers in training the opportunity to become familiar with typical school conditions and acquire skill in the art of teaching. Knowledgeable faculty teaching courses for the college students, coupled with excellent schoolteachers in the primary-grade classrooms, provided an outstanding real-life "lab" experience for the teacher education majors. The close location of the training school right next door to the college was also very advantageous for easy access for all college students in the program. A rural education department was also established for providing services for schools in the outlying areas and was an additional important aspect of the teacher education program, with the college students bused to those schools. Many different subject areas for instruction were covered in the program, including reading and literature. Young campus schoolchildren here listen intently as their teacher reads from a book in their classroom at the Congdon Campus School.

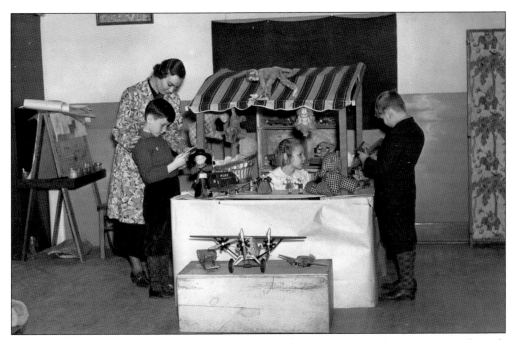

Learning frequently was a very active process. The kindergarten classroom contained much apparatus for use by young children, and first-grade and second-grade rooms contained library corners and aquariums to pique the interest of the students. Here, two students visit the Toy Shop to examine the wares, while another young student assists them with their toy selections.

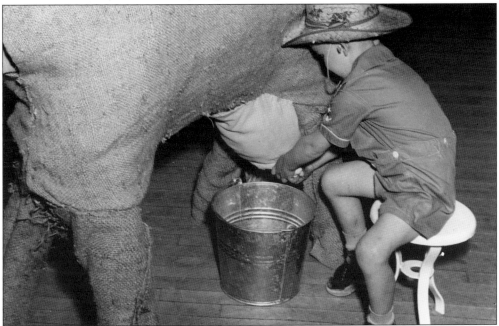

While no information is provided with this photograph to indicate if this scene reflects an active learning experience or some type of production for an audience, this young student is clearly working hard with the indoor resident cow to produce milk in his pail and is dressed for the necessary work as a farmer.

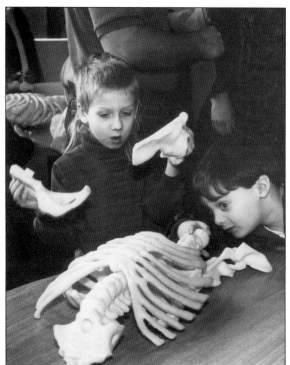

Some puzzles are harder to solve than others—especially those that are more realistic. These two children are concentrating on their work to determine the proper locations for their fake human skeleton parts. Important guidance from their teacher will help them to complete their task in good form. (Photograph by Richard Bitely.)

To help resolve crowded conditions for the normal school and campus school, an additional portable wood-frame structure containing two classrooms was constructed in the late 1940s. It is unknown how the building got its name—the Little Pink Schoolhouse—but it was used for campus school classes for only a few years. It was located between Congdon School and the main college building.

Student crossing guards assist a line of young students with their teachers in crossing Main Street in Potsdam as they leave from the Congdon School and the college's main building. Community and civic duty were emphasized as important for all and started at even very young ages at the campus school.

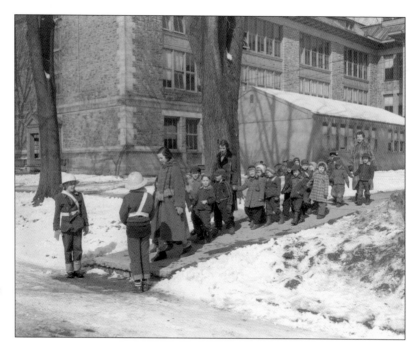

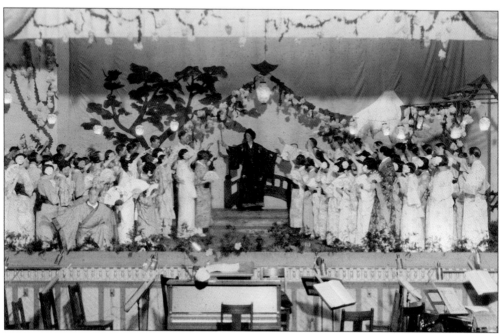

On a number of occasions, the college students from Potsdam Normal joined forces with the training school students for dramatic productions and musical performances. This production of *The Mikado* in the mid-1920s was one such joint performance. The opportunity to work together was beneficial for both the college students and the young training school students.

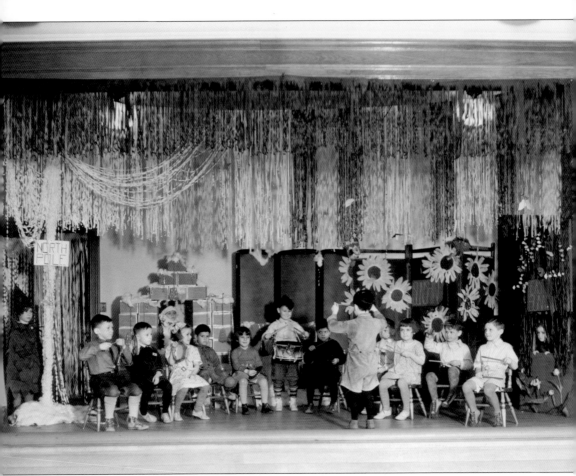

In this undated image of a Christmas pageant held in the Congdon School auditorium, the young children are showing their musical skills as part of the activity taking place at the North Pole. The student performers are directed by a classmate brave enough to serve as the conductor. It is unclear if this production consisted of just one class or if it was a combined effort of several classes. School dramatic productions were an important part of the educational experience for the students attending the school, and some of them included much music as well. The availability of the strong music education program at the college provided experienced teachers and student teachers in many aspects of music for the training school, including instrumental and vocal works. The holiday season is always a time when performers and audiences particularly enjoy participating in music of the season, both reflective and joyous.

The Congdon School auditorium was a familiar sight to teachers, teachers in training, and parents for many plays, productions, and musical performances by the young students attending the school during its many years of operation. For larger productions requiring more space for performers and audience, as well as more extensive sets on stage, the auditorium in the main college building was available for use. Assemblies for the school were also held in the auditorium, and the school was fortunate to have such a large devoted space with good audience seating, as compared to today's more typical setting of combined cafeteria and auditorium in many public schools. In addition to the auditorium, the Congdon School also contained a gymnasium, library, kindergarten room, cafeteria, health offices, science laboratories, and demonstration rooms for the enhancement of instruction for student teachers. (Photograph by Clarence Premo.)

During the time period when the campus school still contained high school grades, commencement ceremonies were held. The class of 1959 is shown graduating here, with the high school students on the stage of the Congdon School auditorium and the band providing music in the pit. The name of the Congdon Campus School was changed to the Research and Demonstration Center in the 1970s.

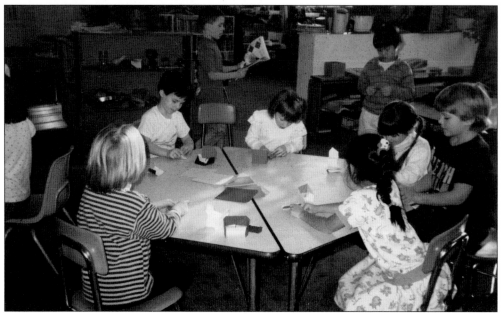

In 1980, the Research and Demonstration Center, with its name changed to Campus Learning Center, was moved from the downtown Congdon school building to the newer Pierrepont Avenue campus of the college. It was located in Merritt Hall, and in addition to primary grades kindergarten through grade six, it also included a preschool program. Here, kindergartners work on their colorful projects in their classroom at the newer school location.

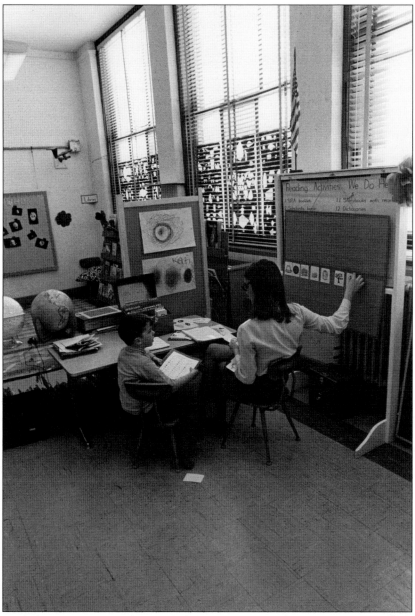

In the 1970s and 1980s, the concept of the Open Classroom for instruction was a fully embraced program at the Campus Learning Center. This newer means of instruction for primary grades was used in a number of school systems throughout the state. As stated by Eunice McKinstry, teacher at the campus school, "It is people who are directly responsible for that program, dedicated to a free, more personalized education for each child, and for each child to learn with responsibility." McKinstry worked in a team of three teachers, with team teaching and multiage groups frequently used in the Open Classroom method of instruction. While to outsiders the Open Classroom method seemed very unstructured, in actuality, the teachers used a highly structured system. Students majoring in teacher education at the college had the excellent opportunity to experience the Open Classroom concept firsthand as part of their educational course of study in preparation for their professions.

Here, a teacher or student teacher engages her young students at the Campus Learning Center in reading instruction at the school's Merritt Hall location. Training teachers in the art of teaching reading in the primary grades has remained an important element of the teacher education programs at the college over all of the years of its existence.

Campus Learning Center art teacher Ellie Uffer helps student Beth Gallagher with her artistic work in this photograph thought to be from the 1970s. Strong instruction in many subject areas was provided, with student teachers assisting. Because of budget problems, New York State began closing its campus schools. SUNY Potsdam's was the last in the state to survive, but it too was closed in May 1994.

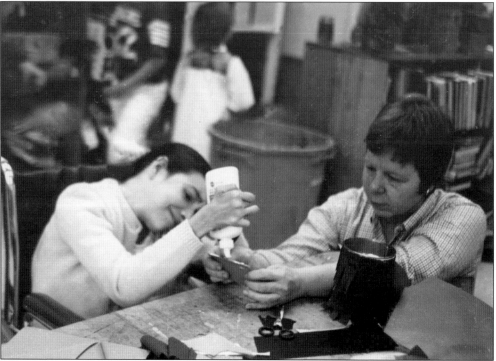

Eight

STRONG LIBERAL ARTS BEGINNING LEADS TO SCHOOL OF ARTS AND SCIENCES

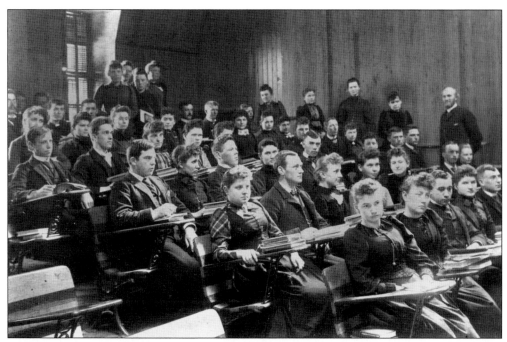

Although the School of Arts and Sciences (first called the School of Liberal Arts) was not officially created until 1972, courses in the arts and science were always important and an integral part of instructional programs on campus from the early days. Here, an early philosophy class from 1891 is seen concentrating on the instructor.

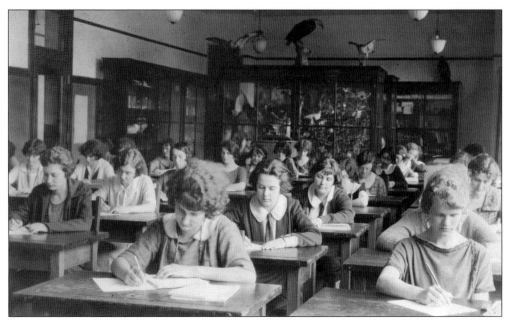

This photograph reflecting an early science class from the downtown campus days is undated. Several specimens are patiently waiting on their perches above to be studied by students. Science classes at the college date to early years, although until the late 1940s, only biology and some physical science existed at Potsdam. Dr. Alexander Major launched what was to become the physics department in 1949, and he started the chemistry department in 1955.

Early science instruction also provided the opportunities for lab experience in rooms specially equipped for such use. This view of a science lab is from the Potsdam Normal days of the then downtown campus. Facilities for the arts and sciences expanded a great deal once the new campus developed on Pierrepont Avenue.

Dramatic groups have existed at the college in various forms for many years. The Dramatic Club began in the 1910s or 1920s and by the 1930s became the Blackfriars, which was an honorary dramatic society for students interested in dramatic productions. Here, members of the Blackfriars group pose in their black robes.

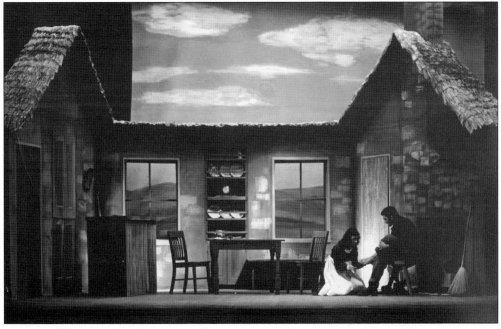

This production of *Playboy of the Western World* is from 1953 and was the first dramatic production to be incorporated into the May Festival, expanding it into the Festival of the Arts. Faculty member emerita Elsie Kristiansen, who served as assistant director for the production, tells the tale of set builders using folded paper towels from the restrooms to construct the roofs seen in this view.

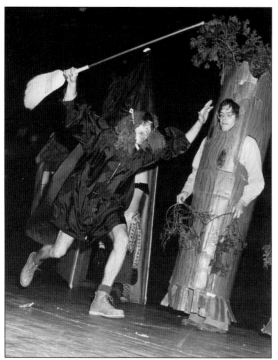

It is unclear if this play is an informal skit or a full-fledged production. The student playing the part of the tree must have found it challenging to move around in his costume. Dramatic arts courses were initially offered within the English department, and in 1970, the dramatic arts department was created, with the first drama major graduating in 1971. (Photograph by John P. Scott.)

Dedicated students provide important lighting for a production. Many students, other than just those visible on stage, work together to make each production a success. In the process, they learn important skills regarding the total effort involved in creating a quality dramatic production. Some will go on to make it their life's work, but all will enjoy putting their learned skills to good use through various venues.

Much hard work is unseen by the audience and requires extensive effort for lengthy periods prior to an actual dramatic performance. Once casting has been announced, students begin learning their lines and stage movements for the production. Here, students rehearse using ladders as part of their temporary set as they prepare for this 1964 College Theatre Guild production.

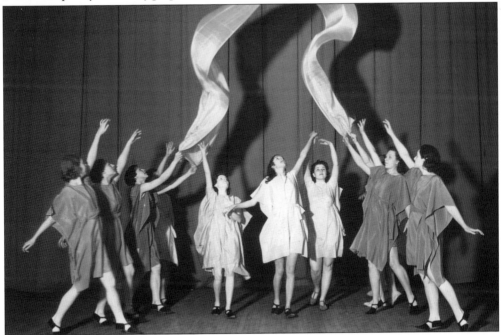

Modern dance first appeared on campus in the early 1950s. This creative dance class was most likely an elective course from that time period. The dance department was formed in 1970, with a dance major established in 1984. Dance merged with drama into one department in 1987, when the Department of Dance and Drama was formed.

Art has also developed a very strong presence on campus. Here, an unidentified art student works on a pottery project with various pieces of pottery equipment also in view. A separate building, Brainerd Hall, devoted entirely to facilities and classrooms for the art department, was opened in 1969. It provided much-needed space for art studios of many types. (Photograph by Laird Chaffee.)

This photograph depicts another student working on his painting project in the painting studio. The art department not only provides instruction in many different facets of the subject for students majoring in art, but it also has classes available in art for students majoring in other subjects who wish to enhance their art knowledge. (Photograph by John Bergstrom.)

In addition to its facilities for the art department, Brainerd Hall is also home to the Gibson Gallery. The campus art gallery provides many exhibits of various types, including artwork of students and faculty, that from area public schools, and visiting shows as well. The exhibitions are enjoyed by not only those on campus but all of the surrounding community.

Frank Revetta, now professor emeritus of the geology department, first established the Potsdam Seismic Network in 1971. Here, he shows and explains some of the seismology equipment in Timmerman Hall. The network is operated by SUNY Potsdam's Department of Geology and over time has been used in earth science, physical geology, geophysics, and seismology courses. Students in the seismology course who operate the network use the data for undergraduate research projects.

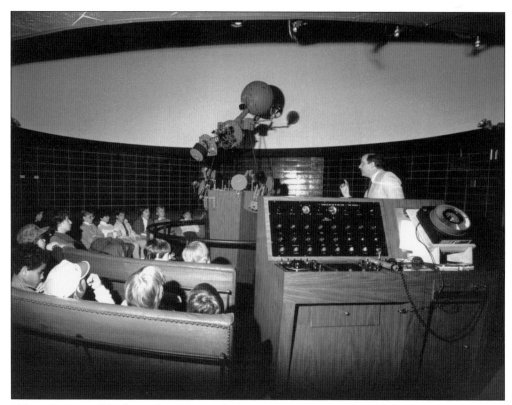

Although not visible from above ground, the college's planetarium in Stowell Hall has been of strong interest and enjoyment for many different types of audiences, especially local schoolchildren. Prof. Arthur McRobbie, a physics faculty member now retired, is shown here giving a planetarium show to such a group of excited children from an area public school. (Photograph by Stephen C. Sumner.)

Students study a boxful of sample minerals and rocks very carefully during one of their geology classes. In addition to instruction in the classroom, the nearby Adirondack Mountains have provided wonderful rock formations for study. Course trips for field experiences head to many different locations.

Chemistry students work hard in their lab as part of their coursework. Newer laboratory classrooms provide much hands-on experience for student science classes at SUNY Potsdam, with many labs of various types located in both Stowell and Timmerman Halls. In earlier years, the east wing of the second Potsdam Normal Building provided a chemical laboratory, science lecture room, and apparatus rooms.

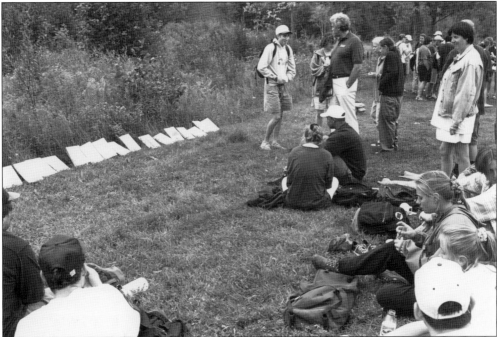

A group of students takes a break to eat lunch while out in the field. This class was part of an Adirondack Environmental Studies Semester. The college's proximity to the Adirondacks has provided wonderful opportunities for instruction not only in geology and environmental studies but also in many other disciplines such as biology, literature, and the arts. (Photograph by Richard Bitely.)

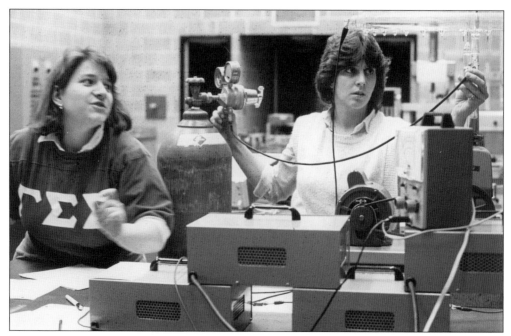

Students are engrossed in their work in a physics lab on the campus. The expansion of space for the sciences into two buildings afforded the opportunity for much more hands-on experience in the lab for all the students in their science courses. Physics is one of the departments now located in Timmerman Hall.

Students help each other learn a new language in the classroom, with assistance from the course instructor. French and Spanish majors have been available for a number of years, with an Arabic minor added more recently. The proximity of the Akwesasne Mohawk reservation has resulted in the availability of the Mohawk language at times as a more unique offering on campus.

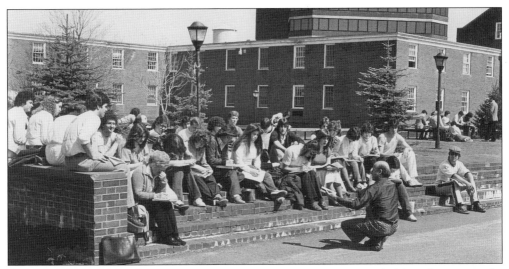

When the weather allows, some faculty from various departments enjoy holding classes outside. Two outdoor classroom spaces are available, but wide stairways on campus also serve the purpose well. Here, Prof. Joe DiGiovanna teaches his philosophy class outside, where teacher and students alike appreciate the fresh air and sunshine.

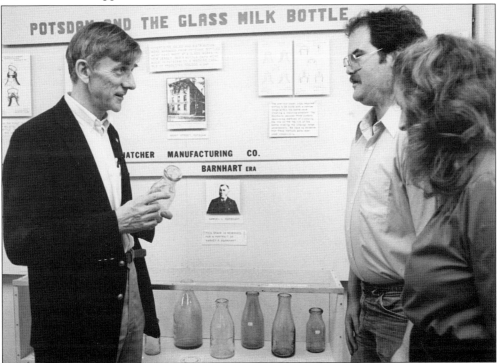

Faculty from all disciplines frequently share their knowledge with others on campus with lectures and poster presentations. Prof. Arthur Johnson, now retired from the history department, discusses his presentation on "Potsdam and the Glass Milk Bottle." Dr. Hervey Thatcher created his version of a milk bottle in Potsdam in 1884. The campus's Thatcher Dining Hall, named for Thatcher, opened in 1961. (Photograph by Stephen C. Sumner.)

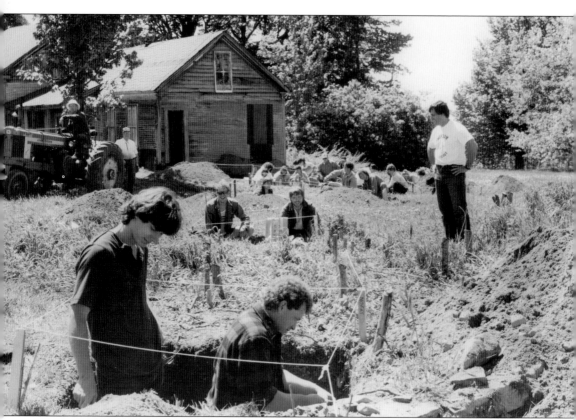

Archaeology classes have done many field digs near and far. This dig in summer 1988 was the first of two done by students in nearby Burke, New York, at the Almanzo and Laura Ingalls Wilder Association farm. Both digs were directed by Steven Marqusee, professor of anthropology. The farm is the actual location and includes the original house of Almanzo Wilder's childhood, as depicted in his wife's well-known historical novel *Farmer Boy*. This particular dig determined where the foundations of the original barns stood for the association's project to reconstruct them in their original locations. Amazingly, Almanzo's recollections and charts done from memory were found to be within inches of the dimensions gathered from the dig. In another dig at the farm, the students were able to uncover an old porch foundation that provided the needed information for the association to find the original location of the front door, which had been walled over many years ago.

Nine

ATHLETICS AND RECREATION

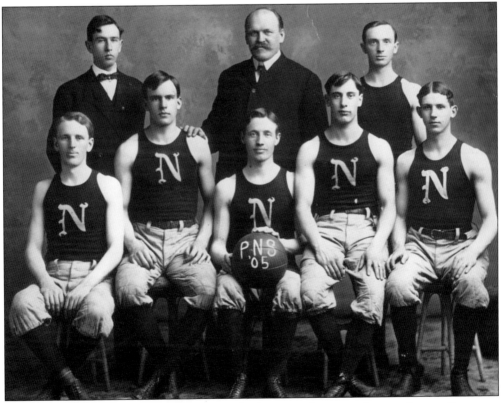

Athletic activities for college teams, physical education classes, and general recreation were emphasized at Potsdam Normal School. Basketball teams were quite important even during the early days of the college and began during the normal school era. Depicted here is a men's team in 1905.

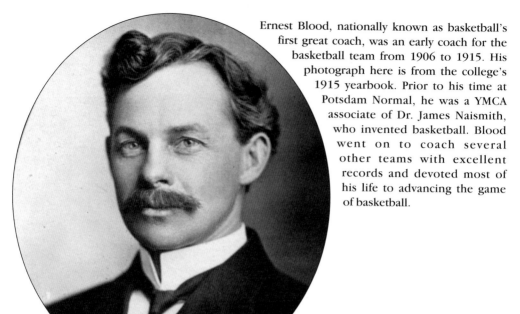

Ernest Blood, nationally known as basketball's first great coach, was an early coach for the basketball team from 1906 to 1915. His photograph here is from the college's 1915 yearbook. Prior to his time at Potsdam Normal, he was a YMCA associate of Dr. James Naismith, who invented basketball. Blood went on to coach several other teams with excellent records and devoted most of his life to advancing the game of basketball.

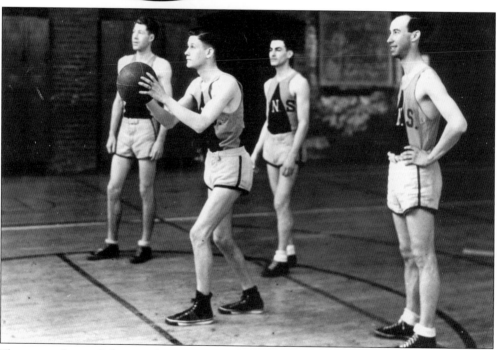

Three members of the Potsdam Normal School basketball team watch as a fourth player practices his shot on the court. The basketball team at this point practiced and played games in a gym located in the downtown Potsdam Normal Building, which also included a balcony area for spectators.

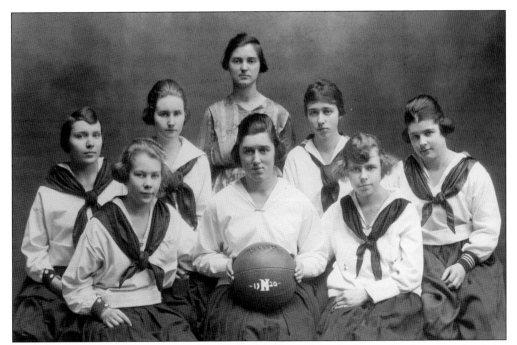

Women's athletic teams were also very popular from the early days. This photograph of the women's basketball team in uniform was taken in 1920. According to one of the yearbooks, the first regular women's basketball team was organized in fall 1920 by John Maxcy, director of physical training. During the war years, when many men were absent from campus because of their active service, the women's teams carried on the athletic traditions.

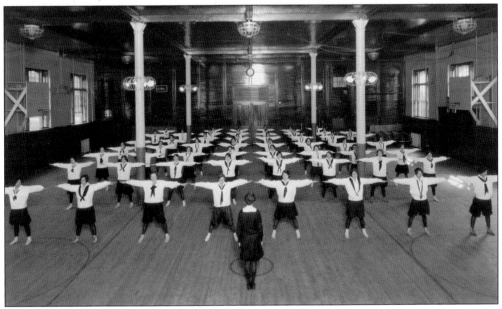

Some physical education classes have stayed the same over the years, but others have changed. This view of a 1921 women's physical education class shows the definite difference both in types of athletic activities normally found during particular time periods and in athletic attire required for women during those earlier years.

Outdoor sports were very popular for many students. A hiking club existed for many years and attracted a large number of student participants. The hiking club members participated not only in hiking but also in other activities, including skiing and tobogganing. Potsdam's many open spaces provided good opportunities for their outings.

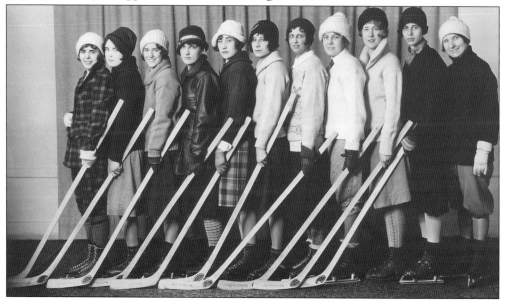

Students from Potsdam Normal School women's ice hockey team from the late 1920s pose in their gear used at the time. Although women's ice hockey teams are considered to be a "recent invention" throughout the country, the college had a team at a much earlier time, which was quite unique in New York State.

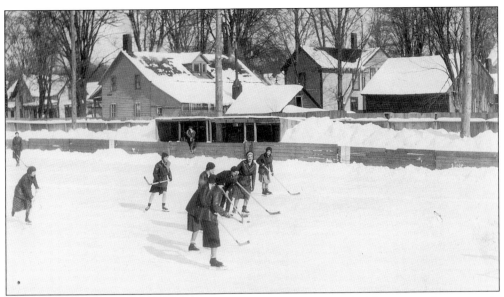

A women's ice hockey team is still around in this 1931 photograph. The team only appears to have existed for about three years, perhaps because (as mentioned in one of the yearbooks at the time) the team members were frustrated that they were not able to find any other women's team to play against in the entire state of New York.

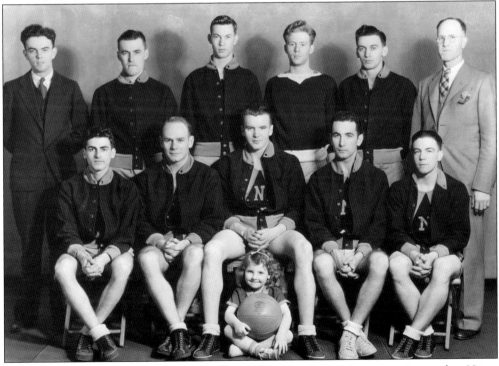

Coach John Maxcy led the men's basketball team for several years. A new sports complex, Maxcy Hall, constructed years later was named for him in recognition of his many contributions to athletics on campus. This picture of the 1935 team includes the squad's enthusiastic mascot, young Sally Maxcy, assumed to be Maxcy's daughter.

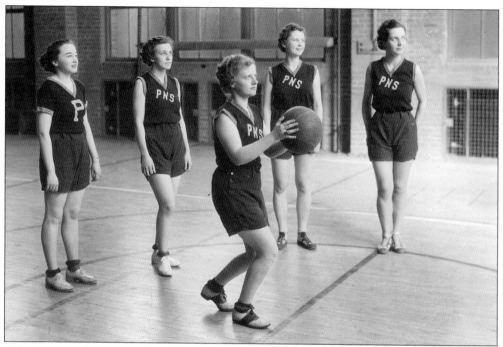

This photograph of women's intramural basketball in 1936 shows one team member taking a foul shot. The women are wearing their official normal school basketball uniforms. A number of indoor and outdoor sports were popular for men and women attending Potsdam Normal.

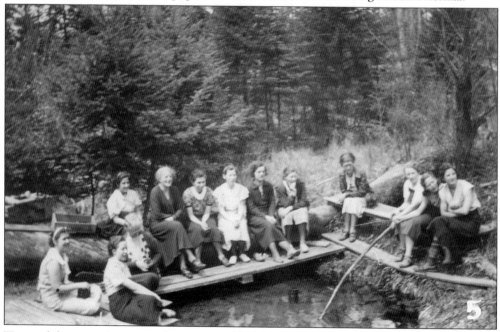

Women hikers are shown out for an enjoyable hike in 1936. The 1930s saw a real growth in sports for all students, a result of then principal Congdon's belief in a "sports-for-all" program. The corresponding hard work of an athletic committee provided more opportunities for many students to actually participate, rather than just watch from the sidelines.

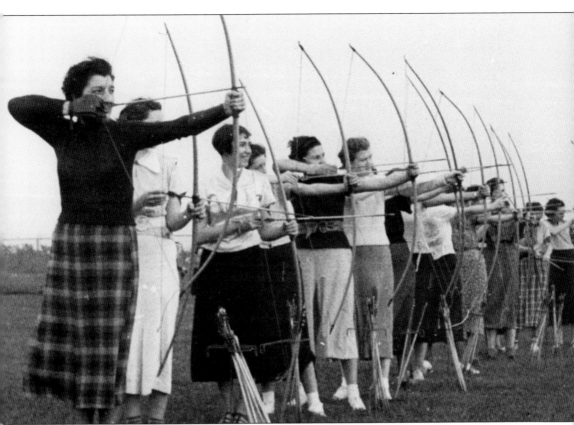

Archery was very popular with both men and women in the earlier years of the college, with a yearbook from 1937 indicating that archery was "a leading sport at our school for the past fifteen years." Here, a group of women practices target-shooting skills in a photograph dated that same year. Other outdoor sports available on the Congdon Field were tennis, golf, various track-and-field activities, handball, softball, field hockey, croquet, horseshoes, and badminton. At the point that the land on Pierrepont Avenue was purchased for sports fields, a veterinary hospital located there was turned into a field house for athletic use. The 1934 yearbook indicates the field house contained showers, lockers, and a kitchen. Lighting was added to the older tennis courts still located on the downtown campus for badminton, and lights were also added to some of the new tennis courts and the archery range, providing the capability for continued play after dark. Federal relief money provided the means for improving and leveling the sports fields.

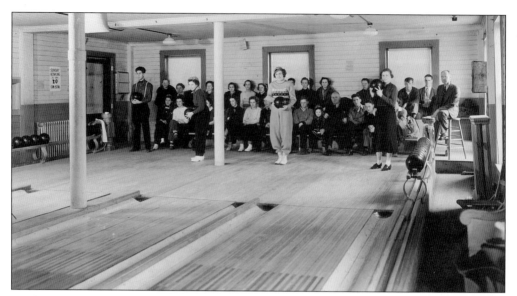

Bowling existed for many years at the college, with many students participating. Alleys were first rented at the Potsdam Club until the mid-1930s. Later, new alleys on Depot Street were made available to students, as seen here in 1937. With new buildings on the Pierrepont Avenue campus, the college had its own bowling facilities in Merritt Hall and then in Barrington Student Union. The alleys were later removed from each.

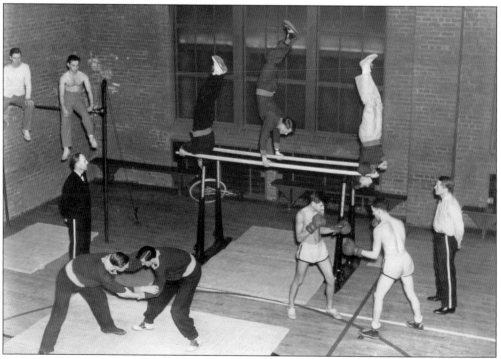

The year 1937 also saw an innovation called "Men's Night" in the gymnasium, which included boxing, wrestling, gymnastics on apparatus, and tumbling, as depicted in this photograph. In addition to these sports and other team sports shown in this book, classes in social dancing and tap dancing were also offered.

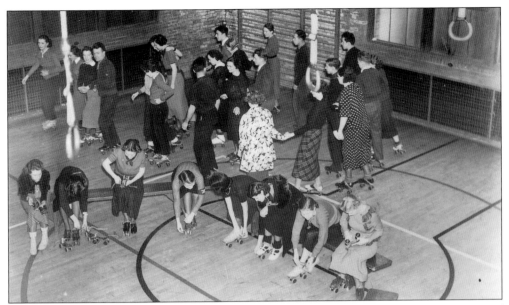

Yet another new activity initiated in the 1930s was roller-skating. Students with a love of outdoor skating were anxious to be able to continue skating when it was not possible outdoors, resulting in indoor skates being purchased and regular skating periods scheduled in the practice school gymnasium. This photograph shows such a session in 1937.

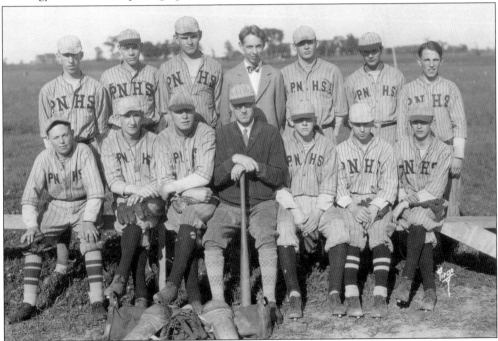

The Potsdam Normal School baseball team was another important group at the college. Here, coach John Maxcy (first row, center) poses with the 1937 players in their normal school uniforms. Evidence exists of a men's baseball squad as early as the 1880s, with a women's baseball team at least by the early 1900s. Although there appear to be periods of time without school-sponsored baseball, a men's team again appears in yearbooks starting in 1950.

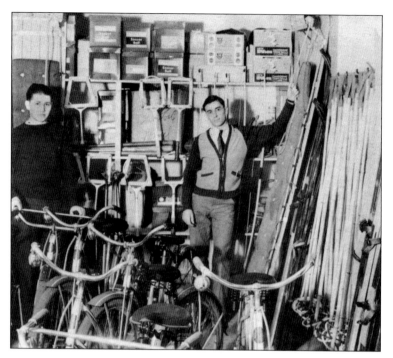

As sports offerings expanded, the outdoor equipment room housed a larger amount and variety of equipment, as seen in this 1938 view. According to one of the yearbooks, the Potsdam Normal School offered one of the most complete and diverse sports programs to be found at the schools within New York State, with sister normals asking at the time, "How does Potsdam do it?"

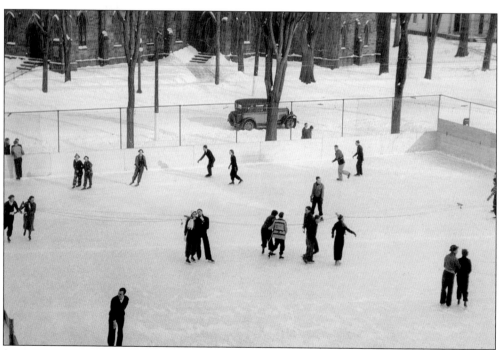

Indoor ice-skating rinks did not make their appearance in Potsdam until later times. The cold and lengthy winters in the area provided many opportunities to enjoy skating outdoors, with both men and women participating. At times, the rinks were located right on college property, convenient for students.

124

Outside recreation was very popular in earlier years and in many forms. This extremely tall and long toboggan run was enjoyed by many students before it became too old and unsafe and thus had to be taken down. It was located behind the future President's House on Pierrepont Avenue, at or near an area of the Racquette River called Matthew's Beach.

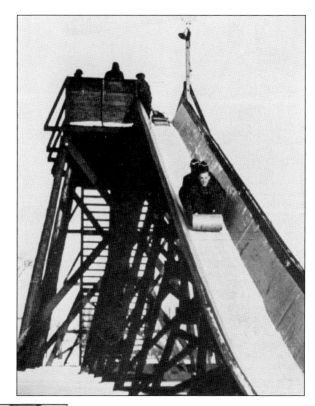

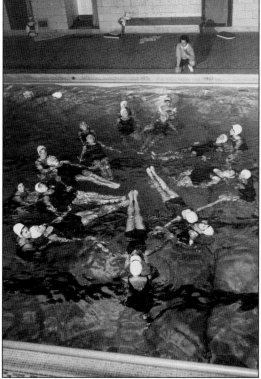

Merritt Hall contained the first indoor pool for the campus when it opened in the early 1950s, allowing swimming to be offered regularly. Although a newer pool was later available in Maxcy Hall, the older pool is still in use for various purposes, including swim classes for area public schools. This Aquatics Club practice is from the earlier times, when the Merritt Hall pool was the only one on campus.

SUNY Potsdam owned its Star Lake Campus for a number of years. It was used for many different needs, such as noncredit summer programs and camps, credit-bearing classes for environmental studies and required physical education credits, and freshmen orientation. Winter activities included a downhill ski slope with lift, as can be seen here.

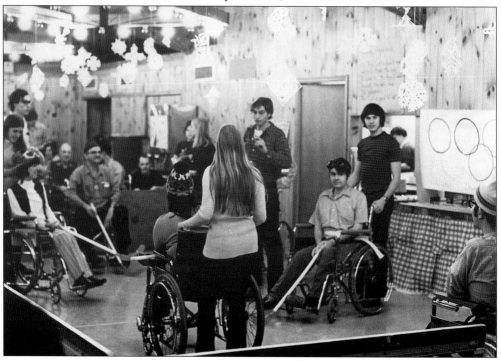

One particularly significant event that previously was held at the Star Lake Campus was the Special Olympics Day. Here, several participants of the Special Olympics are assisted by college students in their indoor hockey event at the main lodge at Star Lake Campus. The Special Olympics later switched to an on-campus location.

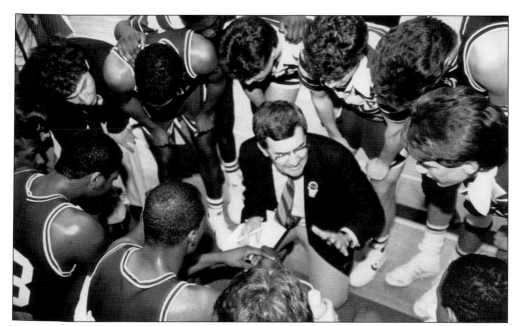

The SUNY Potsdam men's basketball team was successful in winning both the 1981 and 1986 NCAA Division III Championships. Coach Jerry Welsh discusses the action with his 1986 team during the title game. Enthusiastic fans provided strong support for the team during the very exciting contest. (Photograph by Richard Bitely.)

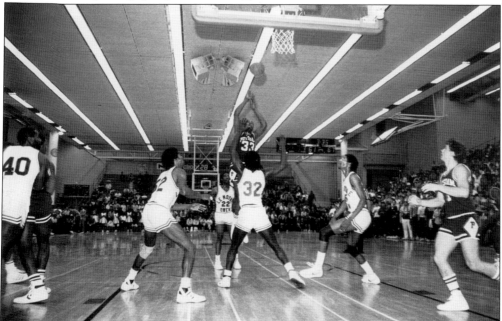

This action shot is also from the 1986 championship game. In honor of the victory and undefeated season, New York State governor Mario Cuomo later traveled to Potsdam to present individual citations and awards of appreciation and excellence. Said Governor Cuomo, "I'm thrilled to be with the best coach in the state and one of the best in the nation." (Photograph by Richard Bitely.)

DISCOVER THOUSANDS OF LOCAL HISTORY BOOKS
FEATURING MILLIONS OF VINTAGE IMAGES

Arcadia Publishing, the leading local history publisher in the United States, is committed to making history accessible and meaningful through publishing books that celebrate and preserve the heritage of America's people and places.

Find more books like this at
www.arcadiapublishing.com

Search for your hometown history, your old stomping grounds, and even your favorite sports team.